CONTE

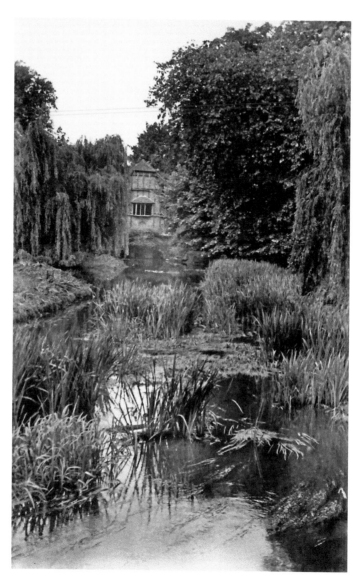

The Old Mill overlooking the River Gade.

CASSIOBURY PARK

THE POSTCARD COLLECTION

PAUL RABBITTS & SARAH KERENZA PRIESTLEY

AMBERLEY

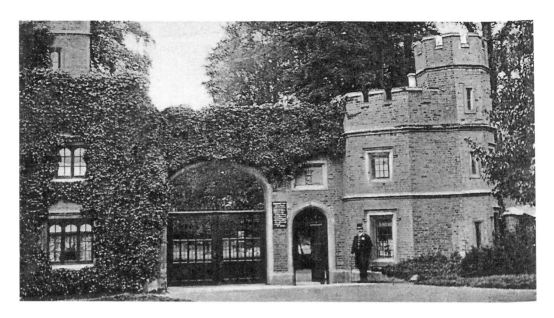

The gates of Cassiobury Park, the once great entrance to Cassiobury House.

For Sheila and Malcolm Jones, Sarah's parents

This book has been supported by Watford Borough Council.

First published 2017

Amberley Publishing
The Hill, Stroud, Gloucestershire, GL5 4EP
www.amberley-books.com

Copyright © Paul Rabbitts & Sarah Kerenza Priestley, 2017

The right of Paul Rabbitts & Sarah Kerenza Priestley to be
identified as the Authors of this work has been asserted in
accordance with the Copyrights, Designs and Patents Act 1988.

ISBN 978 1 4456 7161 1 (print)
ISBN 978 1 4456 7162 8 (ebook)

British Library Cataloguing in Publication Data.
A catalogue record for this book is available from the
British Library.

Origination by Amberley Publishing.
Printed in Great Britain.

INTRODUCTION

In 2014, *Cassiobury: The Ancient Seat of the Earls of Essex* was published and was extremely well received locally and nationally. It told an incredible story. Prior to this, the history of Cassiobury was relatively unknown. Certainly, there was some local knowledge of the once great house and the parkland remnants that now make up Cassiobury Park. The book told the full story, from the early days through to the arrival and impact of the great families involved, to the inevitable loss, demise and downfall of these families and ultimately, the break-up of the estate. Their loss was the ultimate gain for the people of Watford, with the purchase of lands and creation of one of our greatest public parks – what became known as Cassiobury Park. The book captured many wonderful paintings and images of the great estate and a number of images of the park when it became a public park for the people of Watford. However, with nearly 200 postcards of the park dating from the early 1900s in existence today, only a few were published. This book is therefore an opportunity to showcase the many late Victorian and Edwardian postcards of the park in its latter days as a country estate to its earliest days as a new public park. The timing of such a book could not be better. Cassiobury Park is about to start a new chapter in its impressive history. Watford Borough Council, through the Heritage Lottery and Big Lottery Fund, have invested over £6 million in restoring this great British

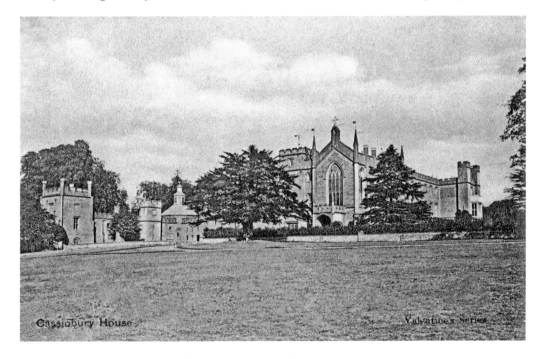

Above and overleaf: Cassiobury House, overlooking 'Cashiobury' Park.

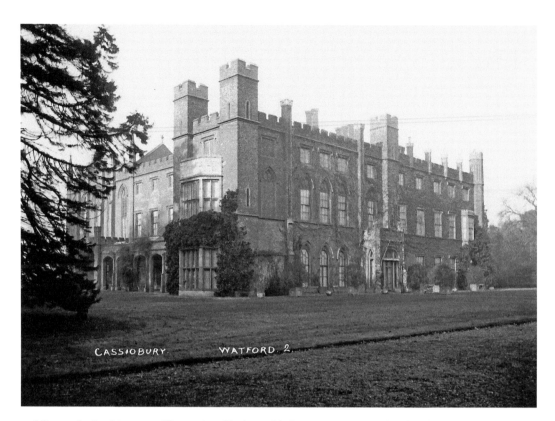

CASSIOBURY. WATFORD 2.

public park; its history will continually be told for generations. This book retells the history in a different way. The use of postcards was often the best, quickest and cheapest method of communicating with family and friends. It was during this era that postcard collecting was firmly established. Picture postcards covered every single subject of interest and parks were commonly covered. Publishers competed fiercely and the many cards of this era thoroughly document much of our local history. Within this book, Cassiobury Park is well documented, with postcards dating from 1903 onwards and it covers the many popular features within the park – the iconic gates, the lost house, the mill, canal and river, as well as the wider landscape, including the bandstand. Many views are similar but the detail within them offers a view into a changing landscape – do look closely at them.

SECTION 1

CASSIOBURY PARK
A SHORT HISTORY

Cassiobury Park is found on the western edge of Watford. It is twice the size of Hyde Park. It is bordered to the north by The Grove parkland and adjacent agricultural land, to the south-west by woodland and agricultural land, to the south by twentieth-century housing development, and to the north-east by the Cassiobury Park estate, a post-war housing estate of high-quality architectural private houses laid out in spacious surrounds. Prior to the 1920s, the south-east boundary was marked by Rickmansworth Road, and the east boundary by Hempstead Road. The eastern tip of Cassiobury Park lies largely on relatively level ground; west of the canal the ground rises steeply to the plateau known as Jacotts Hill, before descending westwards through Whippendell Wood. However, on a low hillside rising up north-east from the parkland looking towards Jacotts Hill, lies the earlier site of the once great Cassiobury House, this area now being completely occupied by housing.

Cassiobury Park is now the principal public park for the Hertfordshire town of Watford, serving not only local people but thousands of visitors from around the region, across Hertfordshire and from north London and beyond. This park has a significant history: it is the ancient seat of the Earls of Essex who lived at Cassiobury House. This history goes much deeper, going as far back as the Domesday Book and to the Dissolution of the Monasteries between 1536 and 1541. History brims in this place. Visitors to Cassiobury Park today are actually stood in the middle of what was once an immense and vast country estate, looking from what was once the Home Park, towards the High Park, of the former Cassiobury House.

In 1910, *Country Life* visited Cassiobury, where the house is described as 'set in great and delightful grounds and surrounded by a grandly timbered park. Therein is peace and quiet; the aloofness of the old-world country home far from the haunts of men reigns there still, and Watford and its rows of villas and its busy streets is forgotten as soon as the lodge gates are passed'. The calm on which *Country Life* commented was not to last. In 1916, the 7th Earl of Essex, aged only fifty-eight, died tragically. Six years later, his widow and his heir, the 8th Earl, who was aged thirty-two, put the house and the park up for sale. The *Estates Gazette* commented at the time that Watford had recently grown into a great manufacturing centre and the estate offered the most natural expansion for the town, with much of the land ripe for building. The house was stripped of its fittings and its contents sold far and wide, with the subsequent demolition of the house in 1927. Parts of the park became a golf course, with some retained as public parkland and the remainder slowly developed as housing ... only seventeen years since *Country Life* had visited. But we shall start at the very beginning.

The name Cassiobury has stimulated debate for decades among historians. Indeed, recent discussions about the origins of the name have concluded that it is probably derived from a male Anglo-Saxon name, Caeg, with *hoh* the Anglo-Saxon word for 'spur of land'. This gives the earliest known name for this area as 'Caegesho', which appears in medieval charters.

The local topography makes this a credible explanation. The spelling changed during the early period but the addition of 'bury' has not been found before 1509, when it appears as 'Cayeshoobury'; in 1544 it was 'Cayshobure' and in 1545 both 'Casshobury' and 'Cayshobury' were in use. The addition of 'bury' to a name in this period was used to indicate a manor house and does not mean that there was a 'burh' here (an Anglo-Saxon fortified site) as has been suggested in the past.

Cassiobury itself first enters early written records when it was part of the Manor of Cassio (or Cashio), which was a vast area of land belonging to the Abbey of St Albans. The abbey chronicles, written in the medieval period, claimed that this manor had been given to the abbey by King Offa of Mercia in 793, though there is no contemporary evidence to support this. The Manor of Cassio is included in the Domesday Book of 1086 as part of the property of the abbey. It is described as including meadow and pasture as well as having enough woodland to support a thousand pigs, which suggests that the area was indeed heavily wooded.

It was Henry VIII's Reformation and the closing of the monasteries which transformed the structure, layout and governance of the Manor of Cassiobury. From 1539, the manor was effectively under new ownership and the rule of the Abbey of St Albans ended. For Henry's friends, the Reformation and Dissolution of the Monasteries was wonderful news. There was an extraordinary amount of wealth in the form of chattels and estates. In 1545, Sir Richard Morison, a favourite of Henry, was able to buy Cassiobury as well as land in Yorkshire, and a new era was soon to begin. Morison's origins were rather obscure, with references to him being born in Yorkshire as well as more locally in Hertfordshire. Richard was typical of the new breed of men coming to the fore on their merit rather than by influence of money or family.

At Cassiobury, Morison had commenced building a house that would match his rising status, described as 'a fair and large House in this Place'. It may be that he also emparked the grounds, but Saxton's map of 1577 does not show a park at Cassiobury and no documentary reference to such a feature occurs before 1632. The Morison's wealth was undeniable and he and his subsequent descendants were clearly interested in property and their careers illustrates this family's social standing. Under the ownership of the Morisons, Cassiobury underwent a considerable expansion. Additional manors were added to the estate and in the 1620s they purchased new properties, including Leavesden Wood (1625) to the east and Jacketts Farm (1620), which would eventually become part of the High Park. John Speed's map of 1611 shows the area of the High Park surrounded by a pale. One would certainly expect someone of Morison's status to possess a deer park, and the lodge in High Park, referred to in later surveys in 1685 may have been built in the seventeenth century as a hunting lodge or banqueting room. Maps of 1676 (Seller) and 1695 (Oliver) certainly show a park at Cassiobury, with both maps indicating a name of Cashio Lodge within the park. In 1628, current incumbent Sir Charles Morison died and Cassiobury passed to his daughter Elizabeth. A year earlier she had married Arthur Capel of Hadham Hall, near Bishop's Stortford, and these two estates were thus brought together. In Arthur Capel, Cassiobury now had an owner who was a keen gardener. The Capels had now arrived at Cassiobury.

With the arrival of the Capels to Cassiobury, so began a new chapter in the history of the estate. In 1668 the Earl of Essex, Arthur Capel, moved to Cassiobury and began a major transformation of the house and grounds. The architect chosen for the house was Hugh May. By the 1660s May's profile as an influential surveyor was significant and he was appointed as Comptroller of the King's Works in 1668. May was one of the four surveyors appointed to rebuild London following the Great Fire of 1666. The 1st Earl of Essex rebuilt the house, with the exception of the west wing, and in laying out the gardens at Cassiobury he employed Moses Cook.

Moses Cook had worked at Hadham Hall for Essex from at least 1664 and began his work at Cassiobury from around 1669. His great strength was his practical knowledge of how to propagate trees, whether it be sowing seed, taking cuttings, layering or grafting. He was a partner in the Brompton Park nursery, which he helped to found in 1681 and from which he retired in 1689, and was the author of *The Manner of Raising, Ordering, and Improving Forest and Fruit-Trees: Also, How to Plant, Make and Keep Woods, Walks, Avenues, Lawns, Hedges, etc.*, first published in London in 1676. In the text, Cook referred to himself as 'gardiner to that great Encourager of Planting, the Right Honourable, the Earl of Essex'. Cook recommended the use of limes, elms and beech and his use of cherry trees and formal, mathematical, geometric planting won him the admiration of John Evelyn, who commented on his use of both, particularly at Cassiobury.

In Cook's book, which he dedicated to the Earl of Essex, he explains in some detail the work carried out at Cassiobury. Cook was already working for Essex at Hadham when, in 1668–69, he began transplanting trees from that place to Cassiobury. Some may have been used to establish new plantations in the park or specimen trees around the house, and others to restock old woodland neglected after thirty years of civil war and changes of ownership. The work to which Cook devoted most attention is in the area known as the Wood Walks. Here avenues were planted along *allées* cut through the wood, thus creating a network of straight walks bordered by young trees behind which were the pre-existing woods. Cook refers to species already growing in the Wood Walks – ash, wild cherry, willow, and 'great timber', probably oak – and a survey undertaken a few years later found that the Wood Walks contained over 900 timber trees, of which 497 were oak. Cook also made recommendations for improved management, including the uprooting of old timber stumps and overlarge coppice stools to encourage regeneration.

To the south of the gardens and the house lay the Home Park, stocked with deer, from which the pleasure grounds required protection. There are two features of particular note in relation to the deer park. Firstly, the open nature of the landscape: unlike the more functional deer parks of earlier centuries, those created in the sixteenth and seventeenth centuries were not for the most part very densely treed, so that open aspects could be enjoyed both towards and away from the mansion. Secondly, some of the trees within the park are shown growing in marked lines. Evidently, hedges had been grubbed out when the park was created but the timber within them allowed to grow on. This was normal practice when parks were created in the seventeenth, eighteenth and nineteenth centuries.

During the reign of Queen Anne, Algernon Capel, the 2nd Earl of Essex was rapidly promoted to Major General and in 1707 to Lieutenant General of Her Majesty's forces. During this time an extremely detailed valuation of Cassiobury was carried out. This valuation of Cassiobury, in around 1685, not only provides a picture of the landholdings and the distribution of wood, meadow and arable land, but also gives an insight into the contents and management of woodlands, enumerating and categorising as it does nearly every tree and giving the age and acreage of coppice. The Home Park, covering 213 acres, contained over 2,000 timber trees (oak, ash and elm) and also underwood – implying that some of the trees were in fenced clumps or small plantations – pollards, and hedgerows. The Wood Walks (16 acres) consisted mostly of oak, ash, beech, and cherry, as well as 8.5 acres of coppice. Across the River Gade, the High Park (282 acres) was similarly rich in timber trees, while areas just to the north of it – Fox Dell, Deer Spring, and Whippendell – were described as 'wood ground and deer park', suggesting that although primarily woodland, they were also grazed by deer and probably included some clearings. They contained some timber and a good deal of coppice: of the 200 acres in Whippendell Woods, 90 acres consisted of coppice at various stages of growth.

Further changes were made to the gardens under the 2nd Earl. He employed George London, who had worked all over England creating formal gardens at great houses such as Longleat, Chatsworth and Burghley. His role as an early exponent of the naturalistic style had only recently begun to be fully appreciated. By 1700, Thomas Ackres was head gardener at Cassiobury, being paid £140 for work in 'the Wildernesse'. His name was linked with further works in the woods just east of the house, formerly part of the Wood Walks. It appears Cook's design of rigidly straight avenues was already being modified to create areas of contrived wildness and irregularity.

The 2nd Earl of Essex died in 1710, and his son William succeeded at the age of thirteen. In the following decades, William Capel was master of Cassiobury; he made further alterations to the grounds. It is known that Charles Bridgeman, the Royal Gardener and a former pupil of London, was also employed at Cassiobury, and was held in such high regard that his bust stood in the house. However no record of what he actually changed or brought to the gardens and landscape at Cassiobury exists. Walpole states that Bridgeman had 'laid out the wood'. Dury and Andrews' map of 1766 shows several features not previously recorded, including a pattern of straight rides criss-crossing Whippendell Wood, and three avenues in High Park. One of these ran from the eastern side of Whippendell towards the house and, according to a later visitor, was aligned to the summer sunset. 'On a distant rising ground you look along a very broad avenue of limes, exactly at the end of which, during a part of the summer, the sun sets...' Another avenue, parallel to the first but shorter, ran east of south-east from the Lodge, while the third ran roughly north–south through High Park. This last one was known as Mile Walk and was an avenue of limes, which certainly postdate the 1685 valuation of High Park as none are recorded.

In 1743, the 3rd Earl died and was succeeded by the second son of his second marriage, William Anne Holles Capel. In April 1758, Lord Essex engaged William Lapidge to carry out work in the grounds. Lapidge was relatively unknown and it was an unusual appointment from such an important client. Lapidge's son Samuel would go on to later work as a surveyor for 'Capability' Brown. Over the next eighteen months, the estate accounts show continued payments to Lapidge for a variety of works, including many simply called 'great work'. Beginning in April 1758, there are repeated references to work on the 'New Waters' and 'Broad Water'. Such work has often been attributed to Humphry Repton, but this work was actually begun more than forty years earlier by Lapidge. The disappearance of the lake can be attributed to the building of the Grand Junction Canal at the end of the eighteenth century. Lapidge may also have been responsible for the construction of the ha-ha by the great house. Although it is possible it could have been adapted from an earlier structure, perhaps made previously by Bridgeman, its smooth curving line suggests that it was purpose-built as part of a scheme to bring fashionable informality to the setting of the house, by removing visible barriers between the gardens and the Home Park. The ha-ha was marked as a strong feature on Kent's map of 1798 and on the first edition 1-inch Ordnance Survey of 1822, and was still extant at the time of the Ordnance Survey in 1871.

The biggest impact on the park was to be the building of the Grand Junction Canal in 1796. The earl was heavily praised for his public-spiritedness in permitting it to cross his land.

Cashioberry Park, Is where we first fall in with the Grand Junction Canal. Ready permission was granted by the present Earl of Clarendon, and the late Earl of Essex, to allow this great national undertaking to pass through their respective parks; and when we find the opposition that the late Duke of Bridgewater was continually receiving, from parties, through whose premises he was unavoidably often obliged to pass his navigable canals, it

must stand as a monumental record, and example, of the urbanity and amor patrice, these distinguished noblemen exhibited for the weal of their country.

The canal was always viewed as a visual asset to the park, often animating the scene with draught horses and colourful craft, though the 'depredations' of watermen had to be guarded against. Both the canal and River Gade entered the park from the north as separate streams; there were two locks and a private wharf on the canal, below which the river rejoined it. They parted again above the Old Mill, near where Iron Bridge Lock and two bridges carrying the drive that linked Home Park with High Park. There were weirs above and below the mill, one of which was visible from the house. Descriptions were many and included:

Adjoining the Grove is a very superb mansion, situated in an extensive and noble park, called Cashiobury. This is the seat of the Earl of Essex, and has lately been repaired and beautified at a considerable expence. The river Gade likewise runs through this park. The scene is much enlivened, by a beautiful water-fall, formed from the waste water, which forms a pleasing object from the house.

The whole scene was much brightened and a favourite view for artists was from a seat in High Park looking over the river and canal as they crossed Pheasant Meadow, with the house on higher ground in the distance.

The 4th Earl died in 1799 and the title passed to his son, George Capel Coningsby. He was a major patron of the arts, taking Cassiobury to its zenith during the first decade of the nineteenth century. Immediately upon his becoming the 5th Earl, George engaged the fashionable architect James Wyatt to remodel Cassiobury House in a Gothic style. The 2nd, 3rd and 4th Earls of Essex did not appear to have made any essential alterations or improvements at Cassiobury, but the 'fifth and present earl has not only given a new character to the house, the park and gardens, but has rendered the whole picturesque, elegant, and interesting'. The appointment of Wyatt was a significant part of the continuing development of Cassiobury, not just for the changes he made to the house, but because his reputation was at that time highly regarded.

A year after engaging Wyatt, Humphry Repton was commissioned to improve the setting of the remodelled house. From Repton's own writings, he was responsible for thinning out the trees at the edge of the Wood Walks, to provide a more open aspect beyond the lawns. Repton's work at Cassiobury was without doubt significant as he refers to it on several occasions.

William Sawrey Gilpin also had an influence at Cassiobury in the 1820s. As a garden-maker, Gilpin was the greatest exponent of the Picturesque style of landscaping. Gilpin set himself up as a landscape gardener late in life at fifty-eight, working into his seventies. Gilpin set up business at an opportune time: Humphry Repton had died in 1818, leaving no obvious heir to his practice. The essence of the Picturesque style was founded on a belief that the eighteenth-century English landscape style introduced by Capability Brown was too sweeping, too shapeless, too smooth, too tidy and too monotonous. It is certainly known that Gilpin advised on plantings and views at Cassiobury, and in particular on varying the size and shape of tree groupings within the Home Park, and opened up a view of the canal that had been deliberately and ill-advisedly obscured by a conifer plantation – presumably by Repton.

Cassiobury forms a striking instance of this mistaken planting. The Grand Junction Canal passes through the park close under a high and finely wooded bank. Under such a

circumstance, the improver, conceiving the canal an unsightly object, made a plantation of Larch, Fir, &c. to hide it: not perceiving that the consequence of hiding the canal would be the exclusion of the wooded bank beyond it – the finest feature of the scene. The plantation is now removed, and the occasional passing of the boats is a source of cheerfulness rather than deformity.

Several architects were engaged in work at Cassiobury during this period. James Wyatt continued working there until his death in 1813, and his son Samuel and nephew Jeffry Wyattville were also employed by the Earl of Essex. It was at this time that many of the delightful lodges and cottages were built, though who was responsible for which building is unclear. Wyatt and his son may have designed the castellated lodge at the main entrance, the lost Cassiobury Gates, dated 1802. In particular, the Swiss Cottage, on the bank of the River Gade, was frequently subject to many paintings, and was intended for the occupation of a family, and also for the accommodation of parties, during the summer, to take refreshment.

Hassell, in 1819 as part of his *Tour of the Grand Junction,* describes many of the lodges, and specifically their settings:

Cashioberry Park is entered by a gate at the lodge, a short distance from Watford ... The lodge at this entrance is a tasteful display of what the visitor may expect to meet with in other parts of the park; it is an octagon building of one storey high, with a profusion of ivy, honeysuckles and roses covering its top and sides, while its back is embowered among lofty trees...

The approach to the Swiss Cottage was via a 'rusticated and monastic-like gate, with a bell placed at its top' and is described as a 'charming place' and 'towards the extremity of the grounds on the left, a rustic bridge is thrown over the river, which answers the double purpose of a weir and dam'. A pretty retreat is found along the banks of the Grand Junction Canal and is 'an excellent station for checking the depredations of the boatmen, who navigate the vessels on that stream'. Nearby is the mill with waterfall where the scenery 'is very picturesque, having an abundance of wood, embowering the mill and cascade, which are continually enlivened, by the herds of cattle and deer'. A cottage called Sparrowpot Lodge is inhabited by one of his lordship's keepers 'at the termination of the Cashioberry woods'. The Canal Company also have a watchman's cottage present 'to prevent the navigators from committing depredations in their passage through the park'.

The 6th Earl of Essex, Arthur Algernon Capell (1803–1902) had many interests, including a real passion for croquet, becoming an enthusiastic promoter of the game. The park was still well stocked with deer and was freely open to the public during the 6th Earl's time. 'To see the house an introduction is required; but the park is always open, and the Gardens may generally be viewed on application to the gardener. They are very beautiful, and have always been famous.' Visitors were able to walk right through the grounds to the north-west entrance at Sparrowpot Lodge, stopping on the way to have a picnic at Swiss Cottage, where they were provided with utensils.

Significant changes were about to sweep through Cassiobury. In 1892, the 6th Earl died. Financial difficulties were becoming apparent. *Country Life* had previously effused about the 'delightful grounds' and 'grandly timbered park'. The new earl and dowager countess were not always in residence and from around 1900 Cassiobury Park was offered 'to let, furnished, for a few months or term of years with Shooting and Trout Fishing'. It was

'thoroughly up to date with several bathrooms, Central Heating, Electric Light, Telephone, etc' and it attracted tenants.

It was during the 7th Earl, George Devereux De Vere's, lifetime that the significant break-up of Cassiobury began, with firstly the outlying properties being sold or leased. Heath Farm (formerly Grove Mill Heath) had been sold to Lord Esher by 1890, and in that year Beech Lodge was also sold. By 1900, farms to the east and south – Callowland, Harwoods, and Cassiobridge – had been sold to the developers Ashby and Brightman. In 1911, High Park was leased to the West Herts Golf Club after 184 acres in the southern part of the park had been sold earlier in 1908, adjoining Rickmansworth Road, again to Ashby and Brightman for high-class housing. The developers offered part of the land to the local council for use as a public park, and the cost implications were to cause a major local furore – the beginnings of the park we know today.

Despite the changes and difficulties, the level of staff employed at Cassiobury was still significant. At one time, there were thirty gardeners and three carpenters (house, garden and estate), three woodmen, a bricklayer, a plumber and a man to attend the turbines in the Old Mill for the private water supply from springs on the estate'. Other employees included a blacksmith as well as at Home Farm, a farm bailiff, a cowman, pigman, carter, dairymaid and a large number of labourers depending on the season. One of the more unusual roles was undertaken by a nightwatchman who took up his duties at 10 p.m. each night and on occasions was 'reinforced by the local police when very distinguished guests or very valuable jewels were in the weekend party'. Along with the lavish parties, on many occasions 'his Lordship allowed the grounds to be used for open air and promenade concerts in aid of charities'. The deer were also still present and at times causing havoc, often getting into the gardens. But after one incident, after devastating the vegetable garden, 'all the deer disappeared'. A bandstand had also been erected in the now nearby new public park and was giving much pleasure to Watford residents but 'the Essex family and those who rented Cassiobury for long or short leases, did not appreciate its proximity as the music could be heard in the house'.

The 7th Earl of Essex died very tragically in 1916, aged only fifty-nine years old, as a result of being run over by a taxi, provoking a significant bill for death duties. Cassiobury was left empty. The 8th Earl, Algernon George de Vere Capel, and his stepmother, the Dowager Countess Adèle, organised the sale of the estate. There was an extensive sale of the contents of the house lasting ten days and the core of the estate was put on the market by Humbert & Flint in association with Knight Frank & Rutley in June 1922. The Sales Particulars announced: 'By direction of the Right Honourable Adèle, Countess Dowager of Essex' the 'Cassiobury Park Estate including the Historical Family Mansion, Little Cassiobury, and the West Herts Golf Links, embracing in all an Area of about 870 acres.' The sale of the contents consisted of 2,606 lots. The house however, failed to find a new occupier and was ultimately demolished for its materials in 1927, 'To lovers of the antique, architects, builders etc., 300 tons of old oak; 100 very fine old beams and 10,000 Tudor period bricks.' Construction of the residential Cassiobury Estate soon began. The land was made subject to restrictive covenants, stipulating that only good-quality detached or semi-detached houses would be allowed.

So to the advent of the new public park? With the availability of land from the sale of the Cassiobury Estate, the council were forward-thinking purchasing land from 1908 up to 1935 when they purchased Whippendell Wood. A poll held in September 1908 to find out what Watford people thought of the idea of buying such land was significant. 'Vote for its purchase and save the Town from becoming a second West Ham' was one common slogan. The Urban

District Council had debated this over a considerable period of time, with opposition even before the poll was held. Ashby and Brightman who were offering the land were keen to progress but were becoming impatient. Writing to the council in July 1908 they said

> As four months have now elapsed since the question of the purchase by the Council of a portion of the Park was first mooted, and our plans for the development of the Estate cannot be completed until that question is disposed of, we think we must ask the Council to arrange that a final decision, subject to the approval of the Local Government Board be arrived at without delay. If the Council determine not to purchase we must at once proceed with the construction of a portion of the new road from the Lodge to the River and with the sites abutting upon and adjacent to that Road.

The results of the poll were announced at the council meeting of 5 September 1908 with a total of 3,644 against purchasing the land and only 679 for the proposal. Thankfully, the council ignored the majority of nearly 3,000 who rejected the plan and bought 65 acres at £24,500, and took up the option on a further 25.5 acres, which they purchased for £7,000 in December 1913. Ashby and Brightman were forward-thinking in their plans and vision. The benefit of a new public park was obvious to them and would certainly be an asset to the new estate they were constructing.

From the council minutes of the time, they were certainly taking their role as landowner of their new public park seriously. In 1910, they were already debating Sunday band playing in Cassiobury Park by the Watford Artizan Band and Watford Military Band and permissions to take collections while playing 'sacred and classical music'. Permission was granted despite objections from Revd J. S. W. Wicksteed, who had written to the council 'protesting against the action of the Council in permitting Sunday band playing'. In 1913, further objections were received in relation to the timing of music being played in the park with concerns 'such music is not provided by the rates during the hours of public worship on Sundays', but was however permitted by the council. Dancing in Cassiobury Park though, was one step too far with a letter received on 22 July 1913 from the Watford Artizan Band asking the Estates Committee to consider. It was 'decided to defer consideration until next season'. A letter from Capt. H. W. Downs was also presented to the council requesting permission for his son to cycle in Cassiobury Park, but permission was denied. Yet requests by the first Troop B. P. Boy Scouts to drill in the park were granted as were requests by D Company of the Herts Regiment Territorials in June 1909.

A potential threat to the park came with a proposed extension of the Metropolitan Underground line in 1912. The extension was to cross over into the park and up the main park towards the town centre to a new High Street station. Thankfully it was defeated by the council. The plan was resurrected after the First World War but was cut back to the present terminus. A further effort was made, this time with premises purchased on the High Street for a station site, but the cost of tunnelling and property demolition was too great and plans were eventually scrapped.

With the estate put up for sale in 1922 and the house demolished in 1927, it was during the inter- and post-war years that Cassiobury was further developed into a town park. Introductions had already included the bandstand, but other new features included a tea pavilion (c. 1926), the laying out of a paddling pool near the River Gade in the 1930s and the laying out of a model railway in 1959. The long northern drive visible on the first edition Ordnance Survey was straightened and planted with a double row of trees and further plantings took place in the park, changing many aspects of its open parkland character. This occurred most notably in the old High Park around the golf course fairways, absorbing the Mile Walk within the woodland. By

1933, the park had shelters, a drinking fountain, a bowling green, hard and grass tennis courts, football dressing rooms, a convenience near the entrance lodge near Rickmansworth Road, new paths and significant planting along the western end of the new tree-lined avenue.

The cottage at Iron Bridge Lock had been demolished, although no exact date exists when this occurred. During the Second World War, a large number of specimen trees were removed from Whippendell Wood and later replaced with silver birch and ash. In the early 1940s, the Swiss Cottage was burnt down. Further tree planting was carried out along the avenue of sycamore and horse chestnut between the park gates on Rickmansworth Road and the paddling pool. The first tree was planted by the then mayor of Watford. A major development in 1954 was the notification of Whippendell Wood as a Site of Special Scientific Interest, indicating the value of this for local flora and fauna. Only two years later, in 1956, the Old Mill was demolished. By the end of the 1950s and into the early '60s, Ordnance Survey maps illustrate the maintenance yard and buildings to the rear of the tea pavilion, which was then a children's day nursery. Car parking was accessed off Gade Avenue and allotment gardens were present in the north-west corner of the public park. Throughout the 1960s, more areas of Whippendell Wood were cleared and replanted with beech and conifers. The conveniences near the entrance lodge were removed by 1964. The same year, 9.5 acres were leased to Old Fullerians Rugby Football Club for ninety-nine years. By the end of the '60s, most of the shelters and the fountain had been lost but park byelaws were now introduced and adopted for the public park for the first time. Such byelaws included 'A person shall not deliver any sermon or any public speech or address or hold or attempt to hold any public meeting in the pleasure ground'; and 'A person shall not to the annoyance of any person in the pleasure ground play any musical instrument in the pleasure ground. Provided that this byelaw shall not apply in any case where the permission of the Council has been given for the playing of musical instruments or singing at any concert or other function held in the pleasure ground in pursuance of than agreement with the Council for the purpose.'

In many local peoples' views, the loss of the gates and entrance lodges on Rickmansworth Road was the most significant event in the park's history. In 1970 it was demolished for a significant road widening scheme. The 'Gothic' double lodge of 1802 was on the site of an earlier lodge of similar footprint visible on Dury and Andrew's 1766 map. The lodge, although popular and loved by local people, was of little architectural value, but was an iconic feature and was important as the terminal point of the grand carriage drive of 1802 and was the principal entrance to the estate from the town. It had survived the break-up of the estate of 1908–22. Its loss was significant as it had the effect of disconnecting residents of Watford from the park's distant history and Watford's heritage in general. Its outline and remains are now mostly under Rickmansworth Road, as indicated by an archaeological excavation in 2014 and further work in 2016.

Another significant removal from the park at this time was the bandstand. Central to the new park had been the introduction of an impressive bandstand within an enclosure. Tenders were being invited in September 1911 'for a bandstand to be erected in Cassiobury Park'. A number of tenders were received including one from the Scottish foundry of McDowall Steven and Co. for a No. 5 bandstand. It was a tender from Messrs Ensor and Ward that was accepted for the erection of a Hill & Smith of Brierley Hill bandstand in October 1911. The *West Herts Post* reported on 20 September 1912:

Cassiobury Park Bandstand – this structure now appears to be shaping up under the supervision of Messrs. Ensor and Ward, builders and contractors, Watford, who have got the work in hand [and] will shortly complete the whole structure. It is to be hoped the fine

weather will prevail... The opening of the new addition to the Park takes place on Wednesday afternoon at 4.30pm when the Artizan Staff Band will render a nice selection of music.

It was formally opened on 27 September 1912 with screens later added in 1914, and there were proposals to extend the bandstand area between 1920 and 1923. Concerts were immensely popular. The *West Herts* and *Watford Observer* reported on 15 September 1923, 'The season's band performances in Cassiobury Park concluded on Sunday with two programmes by the combined bands of the Coldstream Guards and the Welsh Guards. In the afternoon, the enclosure was full, but at the evening performance the accommodation was taxed to overflowing, and thousands congregated around the bandstand'. In 1930, sales brochures for local estate developments describe Cassiobury Park's natural amenities 'with a band enclosure with seating for 1,500 people. First class military bands give performances every Sunday.'

By the 1970s the bandstand was in a terrible condition and by 1975 was in pieces in the council depot. Attempts to reach a decision to re-erect it caused consternation locally with one councillor complaining about its proposed new position next to the library: 'I never thought this was a suitable place for a bandstand but having got a stupid concrete base we have got to do something with it.' Feelings were running high with some local people keen to ensure it was saved and re-erected. They certainly did not want to see it lost forever. It was subsequently reassembled but was never intended 'to be used by a band or for musical entertainment' but as 'an architectural feature'. Its condition was poor, missing its soundboard and it had an unsympathetic felt roof. Either way, it was used on occasions as a bandstand and remained much loved by local people.

By the late 1970s, the tennis pavilions had been lost as well as the last trees from the avenue that comprised the Mile Walk in High Park. However, one of the most popular introductions to the park during the twentieth century was the new paddling pools and kiosks, introduced in 1983 at a cost of £250,000. These replaced the original paddling pool by the River Gade. The *Watford Observer* reported,

> The new-look complex has three separate pools all at different depths to suit all ages of children... In keeping with the circular design, plans show a handful of hut-like buildings at the entrance end of the complex. These will house a kiosk, shelters, stores and lavatories. Council designers have also put forward attractive extras to decorate the pool area. Fibreglass animals at the pool's edges and other features within the water are just some of the decorations that could be added.

Two further significant events occurred in 1987. Firstly, Cassiobury Park was listed in English Heritage's Parks and Gardens of Special Historic Interest at Grade II. The entry is important as it recognised the historic importance of the Cassiobury landscape through three centuries and not just of the current parkland, but also of the former High Park, Jacotts Hill and Whippendell Wood. The second event occurred in October 1987, which was the Great Storm that decimated historic landscapes across the south-east of England. Cassiobury Park and Whippendell Wood lost significant specimen trees, as did many other parks in the region. By the early nineties, active management of the last working watercress beds had ceased and they fell into disuse. In January 1999, the tea pavilion was significantly damaged by fire. Having previously operated for a while as a children's nursery, it was reopened in 2003 after a substantial rebuild, as the Cha Cha Cha Tea Pavilion. In 2009, the park also celebrated its centenary with the unveiling of a new playground.

By 2010, the park was attracting nearly two million visitors, and despite its popularity, its overall condition was of concern with infrastructure declining, and quality of features such as toilets, paddling pools and car parking deteriorating. Furthermore, the landscape structure so carefully considered by many of the earls' noted designers was becoming compromised with loss of views, areas overgrown, the river and canal detached and features such as the mill remains becoming lost in undergrowth. In 2011, a bold restoration plan was embarked on to invest heavily in Cassiobury Park and ensure the long-term sustainability of now one of the country's most popular parks. By 2015, Watford Borough Council had been successful in being awarded £5 million from the Heritage Lottery and Big Lottery Funds with a further £1.6 million from the council itself. With restoration works underway in 2016 and due for completion in 2017, the restoration has seen the return of the original bandstand to its rightful place in the park, minus its felt roof and with a new soundboard; the pools revamped; the lime avenue restored and the former view opened up towards where the house once stood; the tea pavilion restored and its surrounds enhanced including the drinking fountain replaced. But the greatest impact is the new park hub building which has replaced the 1980s buildings, creating a new experience for the park user of today.

The park restoration of 2017 acknowledges the existence of the lost gates within the new design but was never going as far as to replace them. Cassiobury Park today has been reshaped, remodelled and restored by Watford Borough Council as many of the Earls of Essex and their great landscape designers have done before them, and Watford Museum continues to celebrate its history. Yet landscapes evolve as Cassiobury Park has done since the Morisons and Capels carved out the parkland before them. But today it is the former Home Park and High Park which is now so loved and valued by Watford residents – Watford's jewel that is Cassiobury Park. As Moses Cook quoted in 1676, 'What Noble Essex did on us bestow, For we our very Being owe to him' Cassiobury remains as 'The Ancient Seat of the Earls of Essex' and a public park for us all to enjoy.

SECTION 2
CASSIOBURY HOUSE

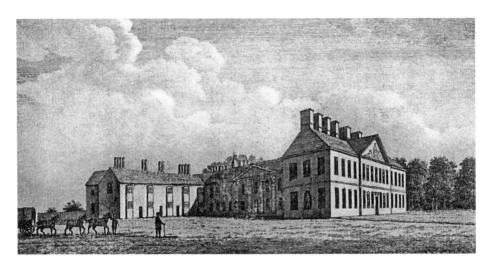

The Seat of the Earl of Essex, 1790, by architect Hugh May, described as 'a fair and large House in this Place'.

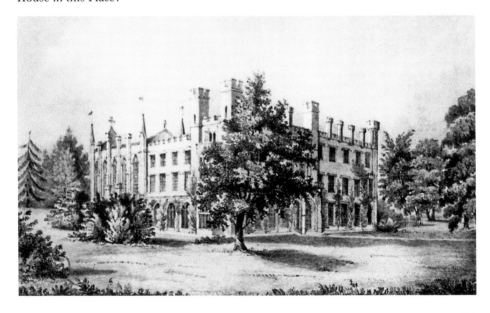

The 5th Earl, George, engaged the fashionable architect James Wyatt to remodel Cassiobury House in a Gothic style (1840).

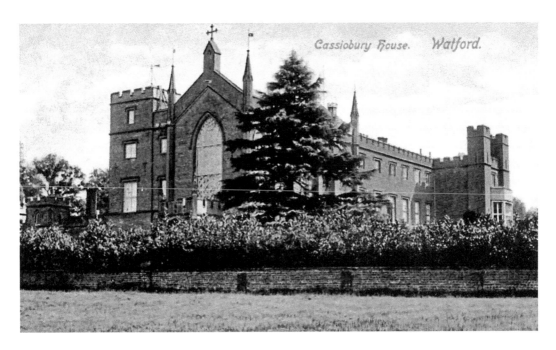

Cassiobury House, overlooking the park with ha-ha. Date approximately 1906. William Lapidge may have been responsible for the construction of the ha-ha. Although it is possible it could have been adapted from an earlier structure, perhaps made previously by Bridgeman, its smooth curving line suggests that it was purpose-built as part of a scheme to bring fashionable informality to the setting of the house, by removing visible barriers between the gardens and the Home Park.

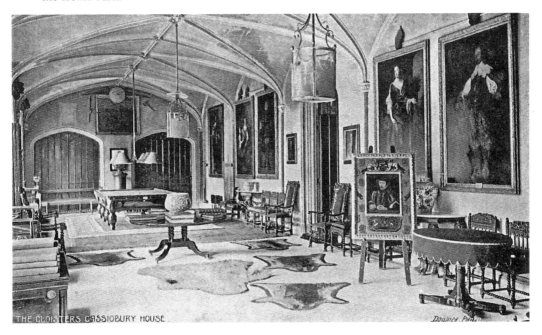

The interior of Cassiobury House was impressive and included the cloisters with the many portraits of the family on display.

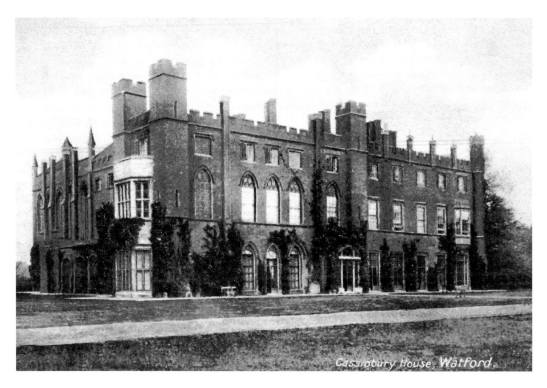

Cassiobury House in 1911, with broad sweeping lawns.

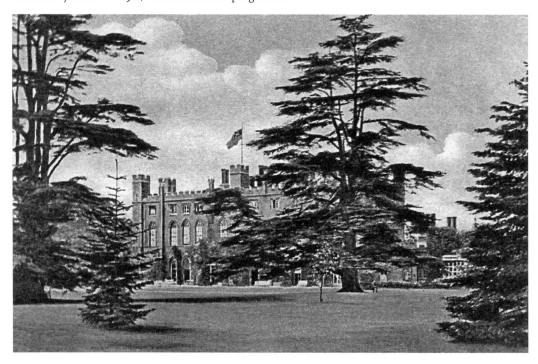

The house with its open lawns between 1900 and 1915 and majestic cedars of Lebanon, some still remaining today.

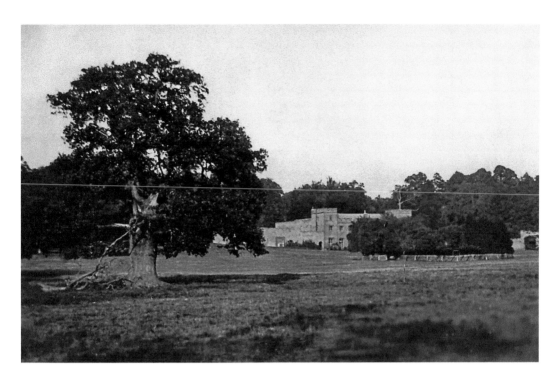

The house as viewed from Cassiobury Park, with the entrance archway to the house from the park visible to the right – the message on the back of the postcard is noteworthy: 'This is the Park in which most of our squad drilling is done. Splendid place indeed.'

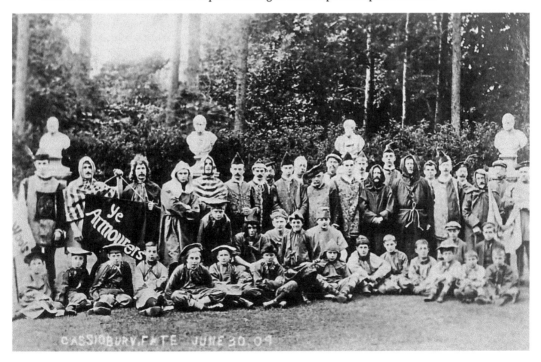

A fête in the grounds of Cassiobury House, dated 30 June 1909.

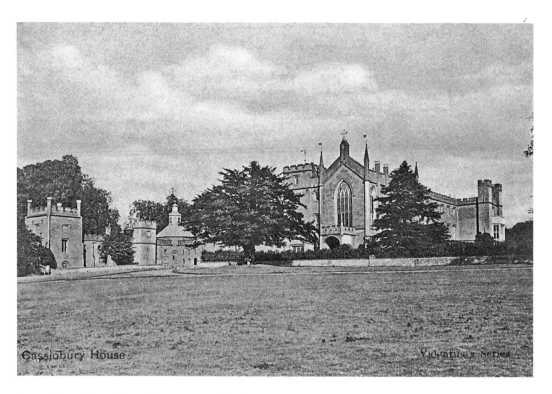

A view from the park and the octagonal kitchen behind the specimen tree in front of the house.

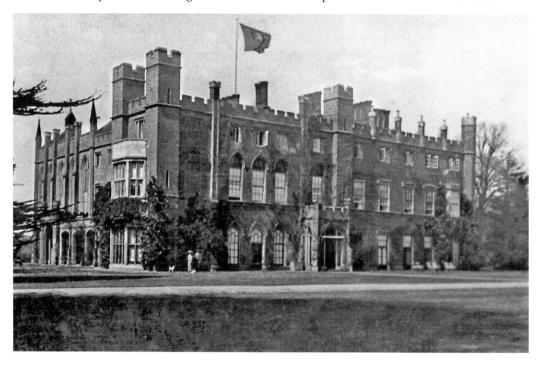

Cassiobury House, *c.* 1920, its decline and ultimate loss imminent. The couple on the lawn with dogs are possibly oblivious to the impending future of this great house.

CASSIOBURY PARK GATES

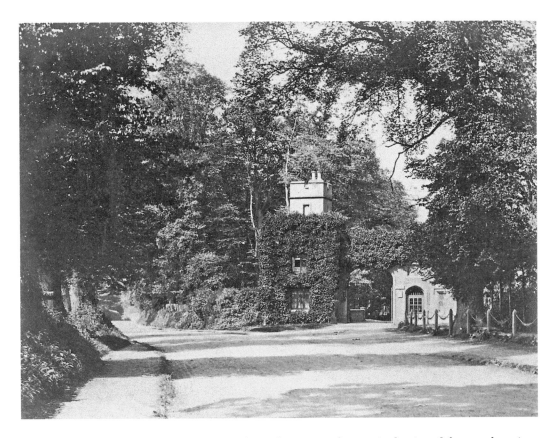

The main entrance off Rickmansworth Road in 1879 – the terminal point of the grand carriage drive of 1802 and the principal entrance to the estate from the town. Described in 1819 as a 'lodge at this entrance is a tasteful display of what the visitor may expect to meet with in other parts of the park; it is an octagon building of one storey high, with a profusion of ivy, honeysuckles and roses covering its top and sides, while its back is embowered among lofty trees...'

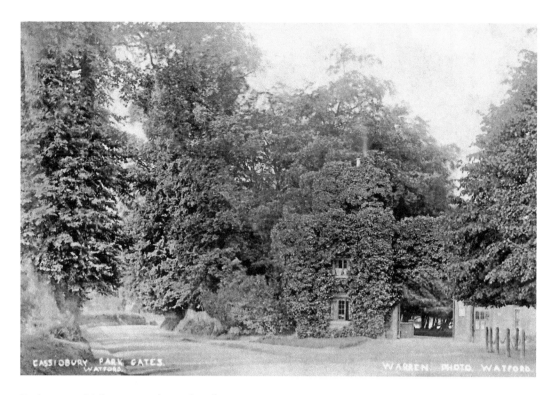

Early 1900s, Rickmansworth Road and an overgrown entrance to the house.

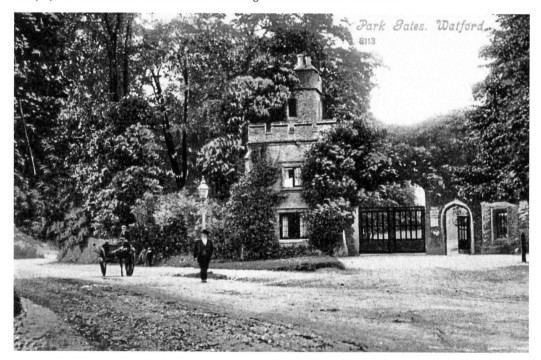

Cassiobury Gates c. 1903, before it was opened as a public park. It is one of the main entrances to Cassiobury House. Rickmansworth Road is nothing more than a country lane.

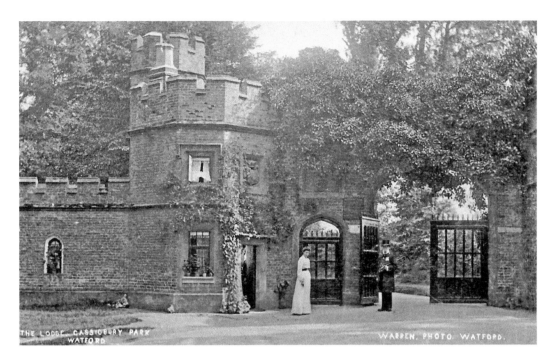

Alice Herring, an employee of Cassiobury in 1898, kept a diary and describes the occupants of the main lodge gate in the park: 'an ex-Guardsman on duty in a dark uniform, (blue-green), tall silk hat, a silver headed cane and his rows of medals across his coat, a most impressive figure to open the large gates'. This postcard is dated 2 March 1916 and is from William to Lucy. He has been on a march to the park and writes 'been in the trenches, rotten, I hope to hear from you tomorrow, so will write a letter tomorrow … I wish I was there, I have been thinking about you'.

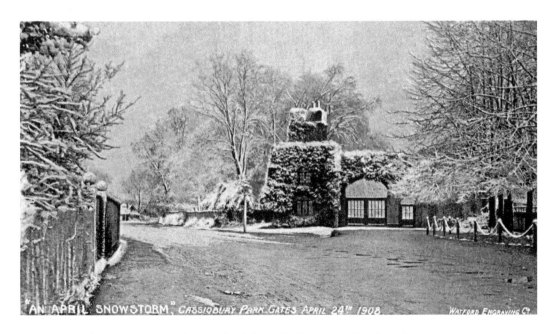

An April snowstorm enveloping Cassiobury Park gates, 24 April 1908.

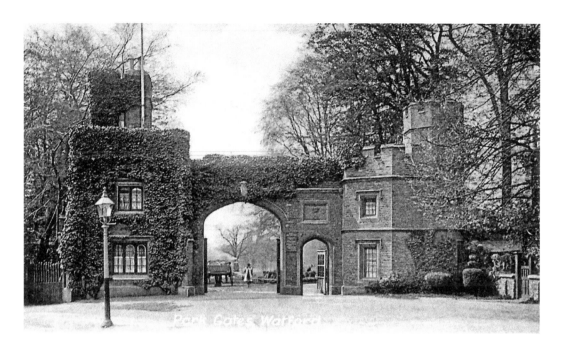

A card dated 1917, with a message to its recipient: 'hope you are looking after all the children well at tea, don't let them have too much sugar will you'. The entrance with planting is now manicured and maintained to a high standard.

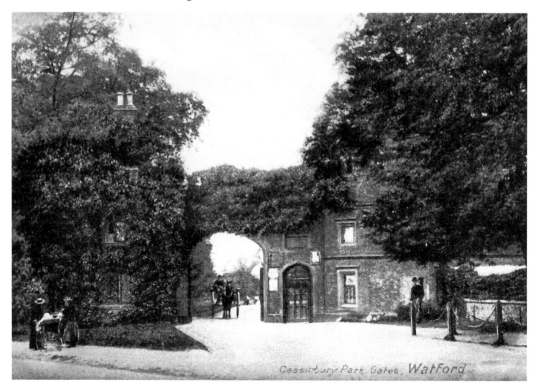

Public access was permitted to the park by 1907, so use of the gates by local people was common.

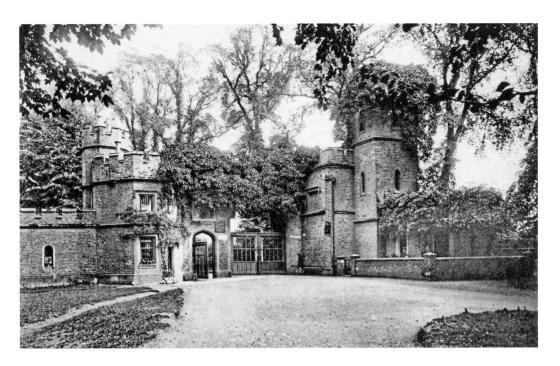

The most common views of the gates are frequently from Rickmansworth Road. There are a number of exceptions. This image possibly dates from when the gates were still part of the estate managed by the Earl of Essex, although there is a notice to the left of the main gates for The entrance and gates are more manicured, *c.* 1930.

An unusual postcard with the inscription 'my dad the chauffeur', named as Thomas Ivanhoe Roberts.

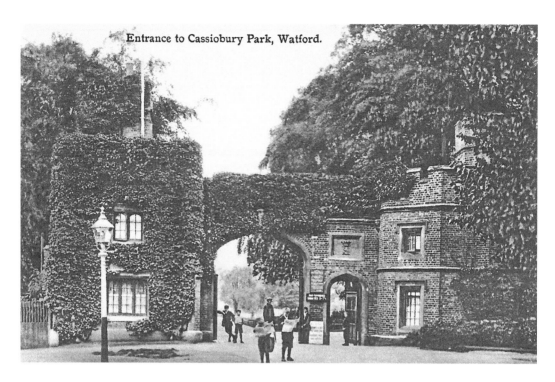

Entrance to Cassiobury Park, Watford.

Young boys by the entrance, casually reading newspapers, complemented by the public notices by the main gates stating 'Band Performance, Sunday 3–7'.

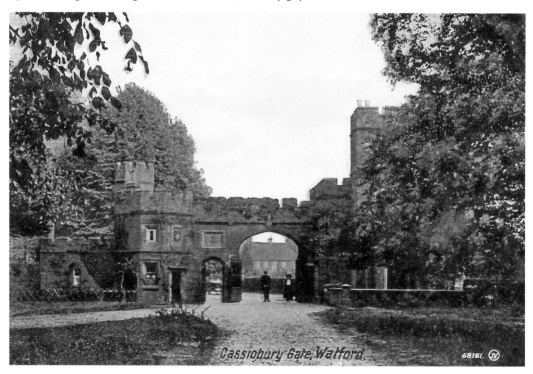

Cassiobury Gate, Watford.

68161.

An unusual image of the gates from inside the park dated 1917, with guardsman on duty?

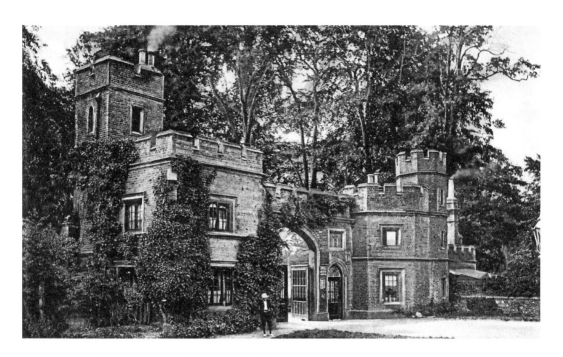

A view of the gates at an oblique angle, date *c.* 1910.

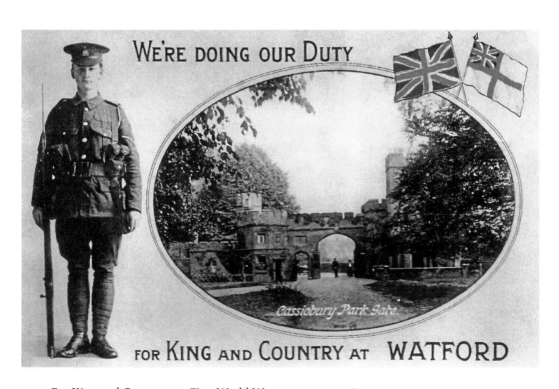

For King and Country, pre-First World War.

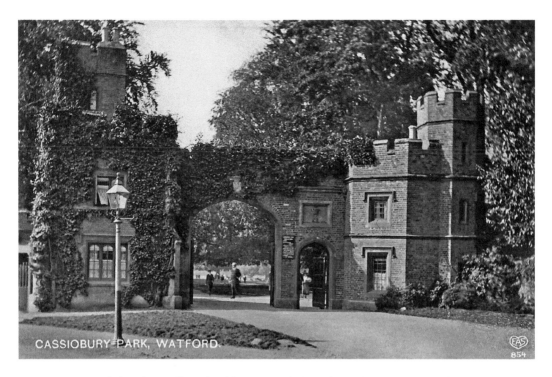

A *c.* 1927 view and already a well-used public park with the rules and regulations well positioned by the main entrance.

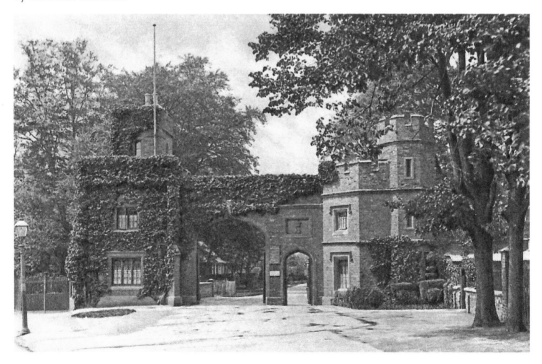

To the left inside the entrance are the new public conveniences installed by the Urban District Council. Postcard dated 1924.

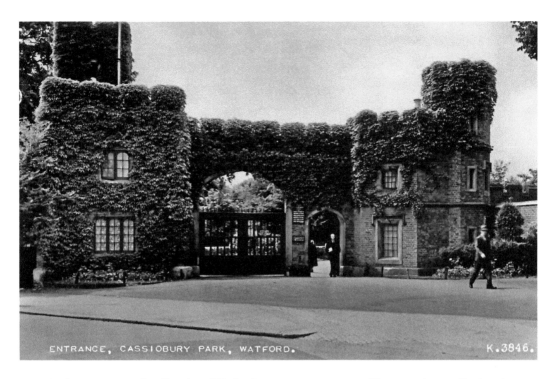

ENTRANCE, CASSIOBURY PARK, WATFORD. K.3846.

Early commuters heading into Watford town centre, *c.* 1954. There are 'no cycling' notices on the main gates, clearly not yet permitted.

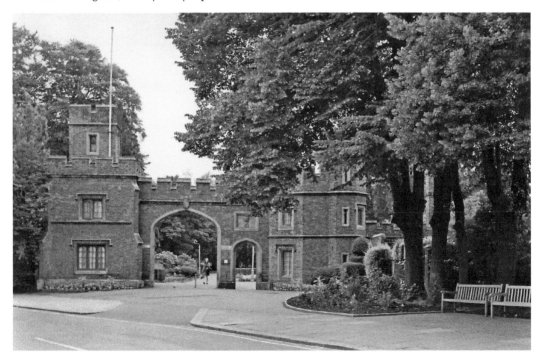

Post-1964 as the public conveniences to the left-hand side have since been removed and formal seating placed by the main entrance.

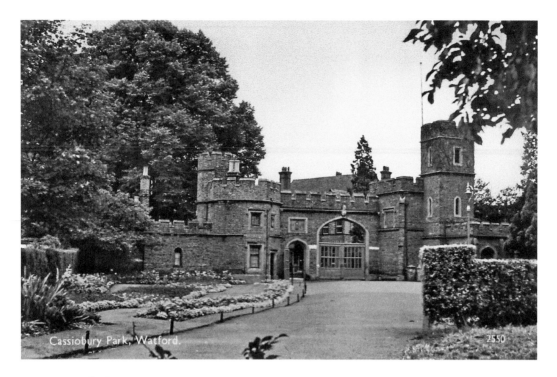

The gardens laid out in the 1950s by the council are well maintained with displays of carpet bedding – as was the fashion of the time.

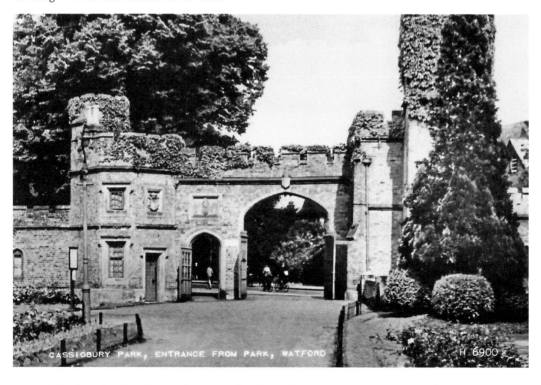

Pruned shrubs, edged borders and very much a formal entrance to Cassiobury Park, *c.* 1956.

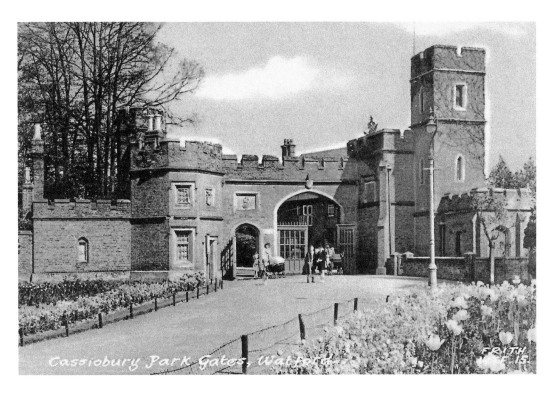

A Frith card, also from the early 1960s with spring displays.

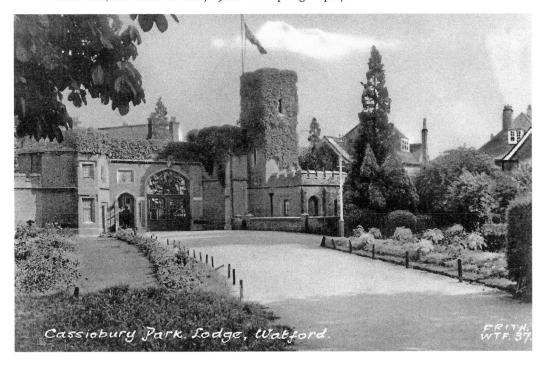

Summer 1962, with the lodge and gates, and ornamental displays in flower. In less than eight years the gates were demolished as part of a road-widening scheme.

SECTION 4
LOST BUILDINGS OF CASSIOBURY PARK

The following buildings, original to Cassiobury Park, have long since been lost, along with the Cassiobury Park gates, but were an integral part of the parkland and its landscape.

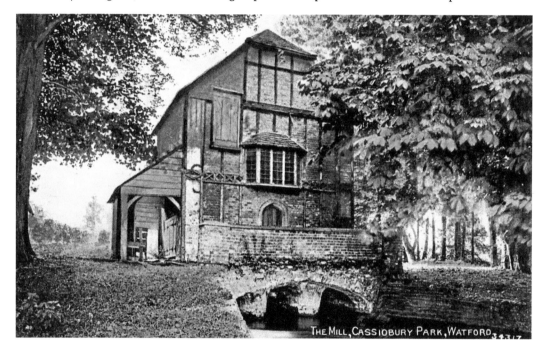

The Old Mill *c.* 1906.

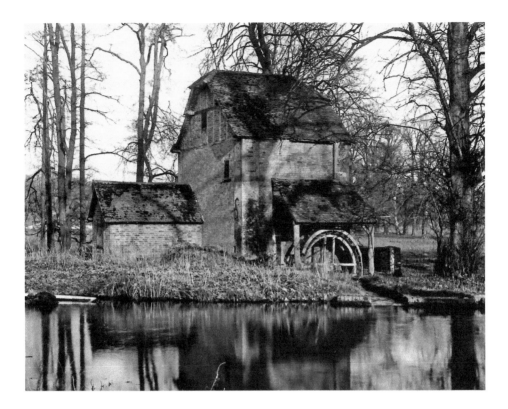

Earl Essex employed a plumber at one time and a man to attend the turbines in the Old Mill for the private water supply from springs on the estate.

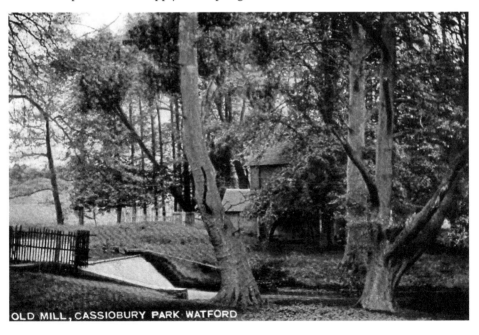

OLD MILL, CASSIOBURY PARK WATFORD

The Old Mill, 1908, lost within the woodland. Areas of the parkland beyond soon became public parkland.

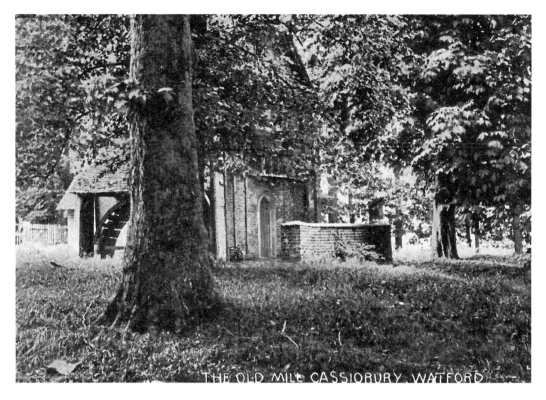

The Old Mill, Cassiobury, with arched entrance doorway.

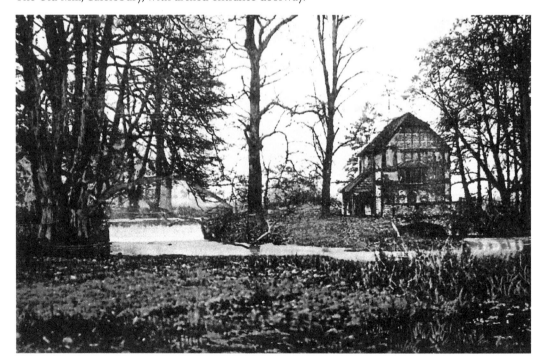

The picturesque Old Mill and waterfall *c.* 1905.

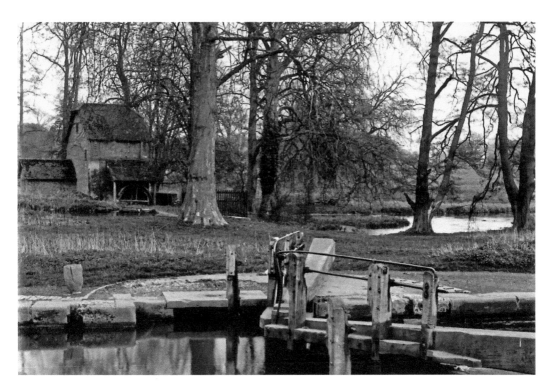

Looking from the Iron Bridge lock towards the Old Mill; it appears to be in poor condition.

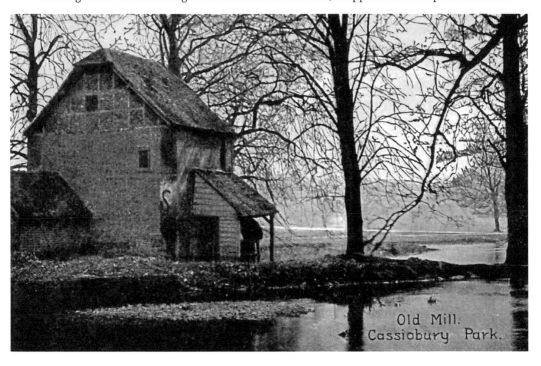

1933 and the Old Mill is disused. Open parkland is visible in the distance, and a much wider, easier flowing River Gade can be seen.

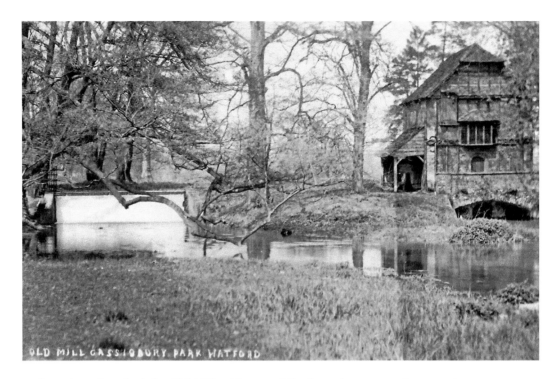

Early writers described the Old Mill with waterfall where the scenery 'is very picturesque, having an abundance of wood, embowering the mill and cascade, which are continually enlivened, by the herds of cattle and deer'.

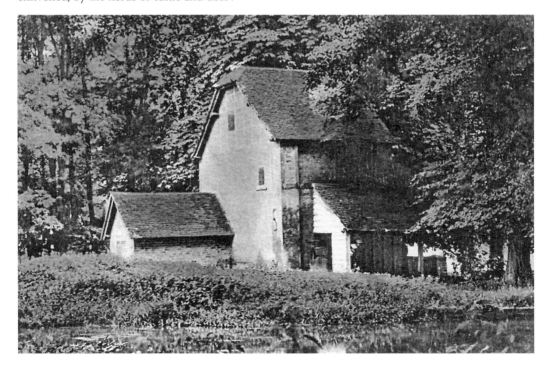

A tinted scene of the Old Mill within the woodland setting, 1906.

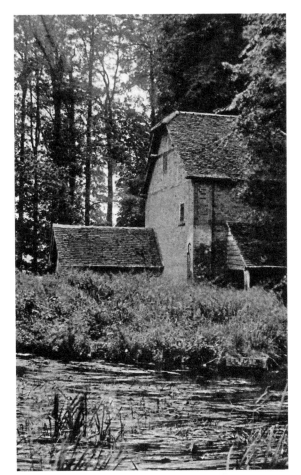

Right: Inscription from a card of 1925 '...a pretty scene within easy reach – just a walk. Trees abound in the district.'

Below: Dated 1950, many postcards give a small glimpse into people's lives of the time. This tells a sad tale. 'Sally is in Scotland, her mother died the day she arrived and Sally never saw her, she was just found dead in her sleep, a shock for everyone. They go back to India on Aug 26...'

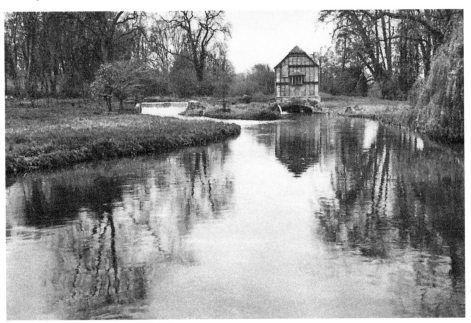

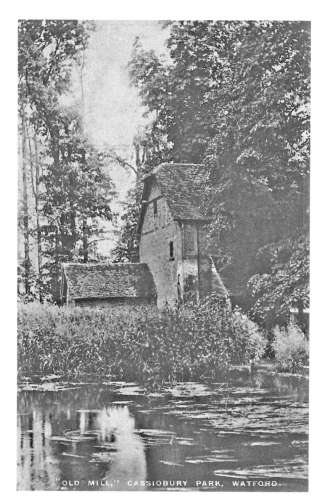

"OLD MILL," CASSIOBURY PARK, WATFORD.

Left: By 1956, the Old Mill had been demolished. It is pictured here with vegetation gradually taking over the area.

Below: The Swiss Cottage, on the bank of the River Gade, was frequently the subject of many paintings and was intended for the occupation of a family, and also for the accommodation of parties, during the summer, to take refreshment.

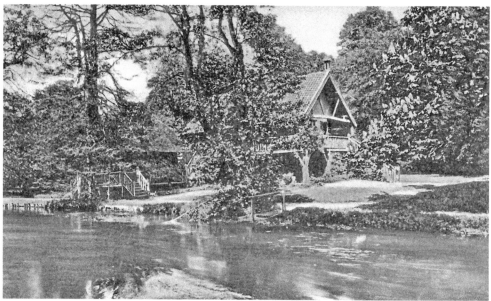

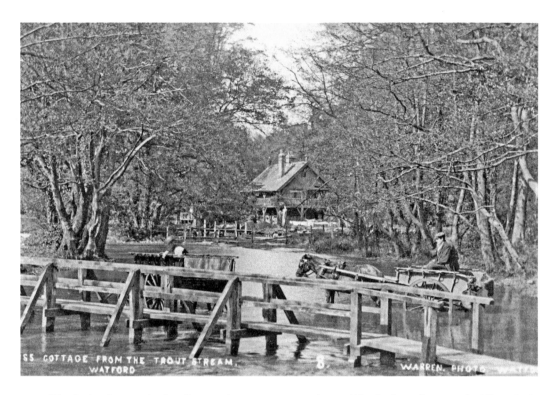

The Swiss Cottage in the distance between 1900 and 1910. The ford used across the River Gade is described here as a 'Trout Stream'.

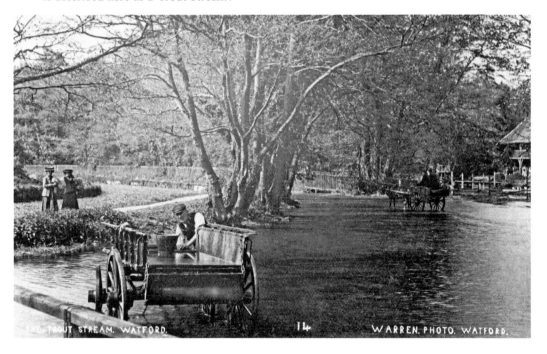

The Swiss Cottage to the right and watercress beds to the left behind the two ladies watching the scene, pre-1916.

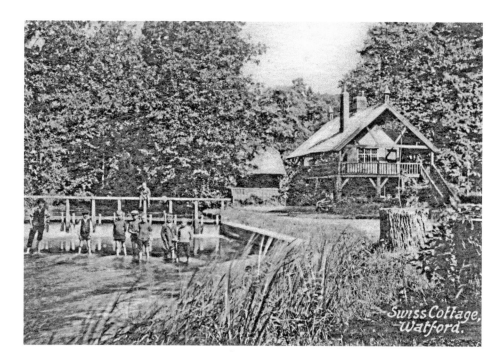

The approach to the Swiss Cottage was via a 'rusticated and monastic-like gate, with a bell placed at its top' and is described as a 'charming place' and 'towards the extremity of the grounds on the left, a rustic bridge is thrown over the river, which answers the double purpose of a weir and dam'. Here, boys are seen playing in the river, pre-1916.

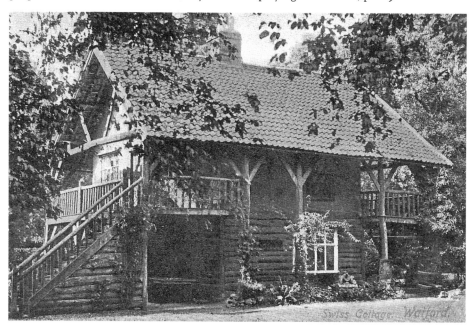

During the time of the 6th Earl of Essex, visitors were able to walk right through the grounds to the north-west entrance at Sparrowpot Lodge, stopping on the way to have a picnic at Swiss Cottage, where they were provided with utensils. Date *c.* 1909.

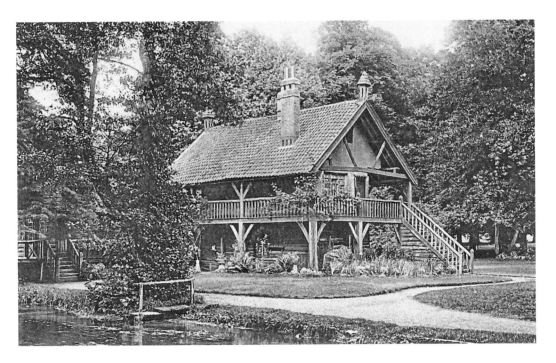

Dated 1904, the card is inscribed 'Have just had a grand ride here'. The Swiss Cottage was frequently used by members of the public as well as the great house itself.

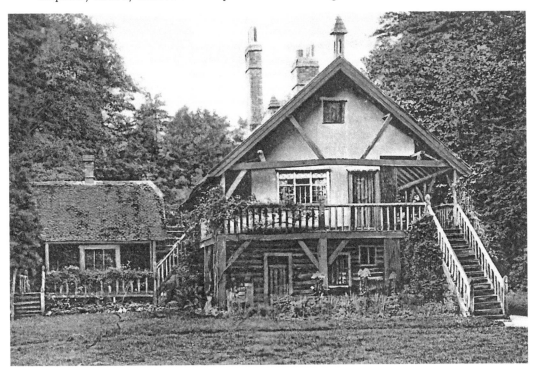

From 1904, the weather is described as 'beastly'. The gardens are well tended and enhance an already picturesque scene within the woods.

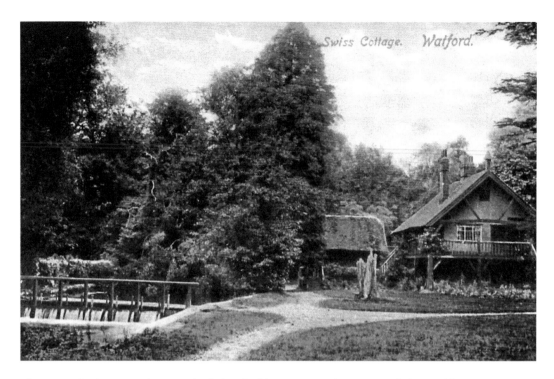

The rustic bridge over the river had the double purpose of a weir and dam, adding to the picturesque scene.

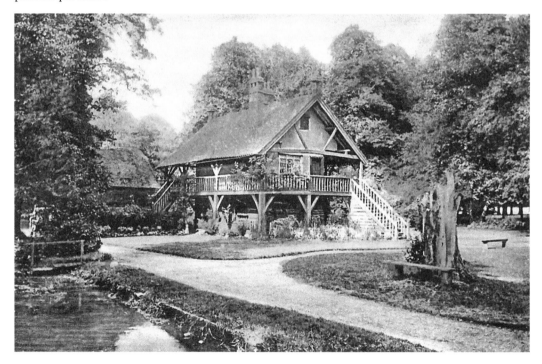

Dated *c.* 1905, the Swiss Cottage, with seats by the river, offered a quiet retreat from the house up the hill.

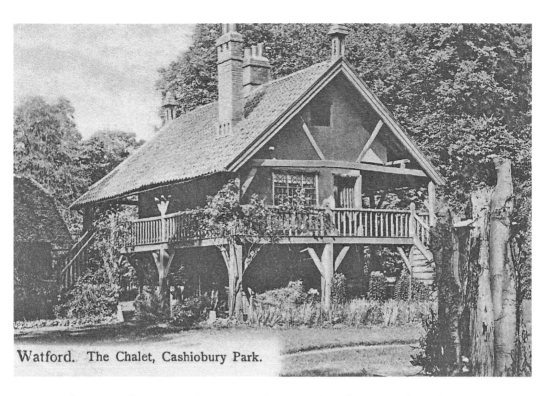

Watford. The Chalet, Cashiobury Park.

Dated 20 November 1905, in this instance the writer describes 'Doctor lanced it. Have got to go and see him again Wed.'

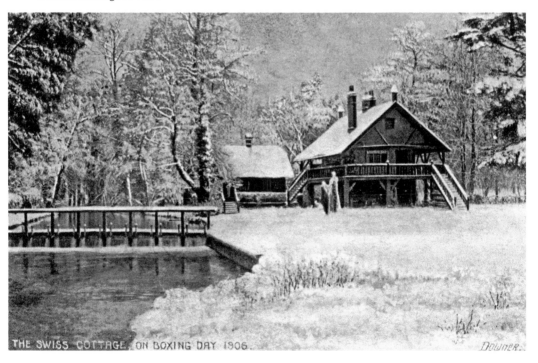

THE SWISS COTTAGE ON BOXING DAY 1906.

Boxing Day 1906, a cold and snowy scene at the Swiss Cottage.

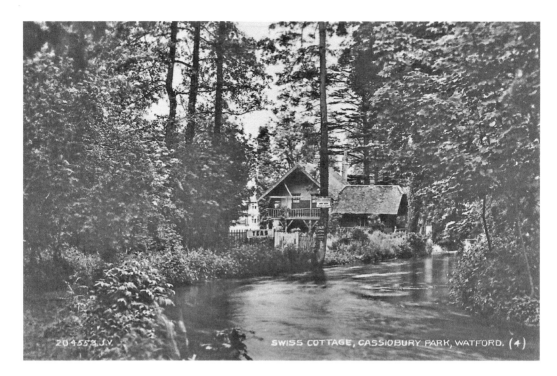

Described by the writer as 'a very pretty spot just outside Watford, reminds me of Chatsworth'. A wonderful image of the Swiss Cottage advertising 'Teas' and 'Tea Gardens'. Houses are visible through the trees. Watford is growing.

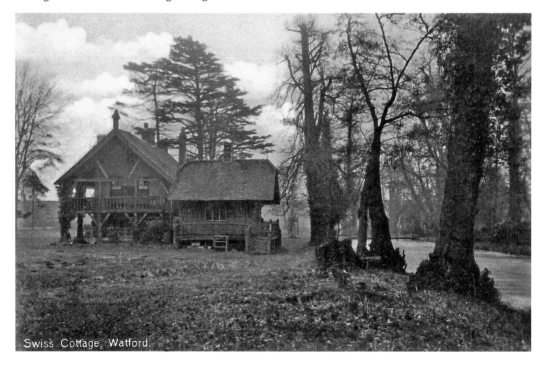

A somewhat gloomy view of the Swiss Cottage, which had eventually burnt down by the 1940s.

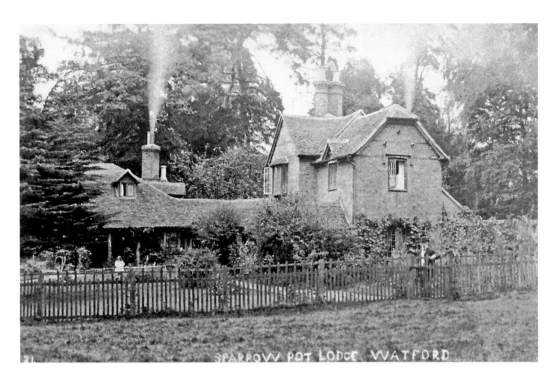

A cottage called Sparrowpot Lodge is inhabited by one of his lordship's keepers 'at the termination of the Cashioberry woods'.

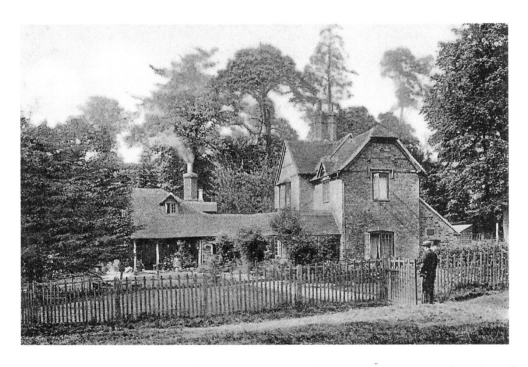

The sparrow pots are evident on the gable end of the house. Sparrows were caught and usually ended up in a meal in the house.

RIVER, CANAL AND BRIDGES

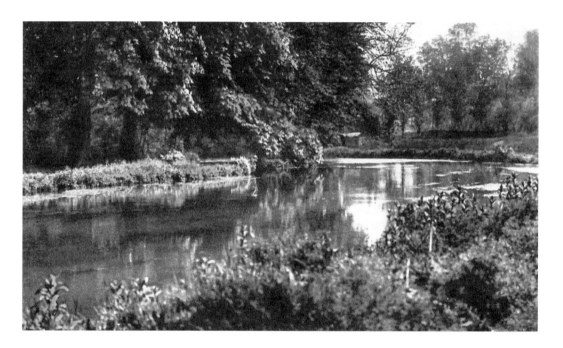

The River Gade has created many picturesque spots within Cassiobury Park over the years.

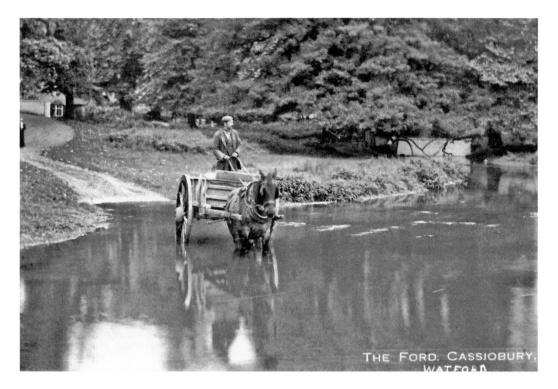

The ford across the River Gade with the Iron Bridge Lock cottage behind and the waterfall set back within the trees, *c.* 1910.

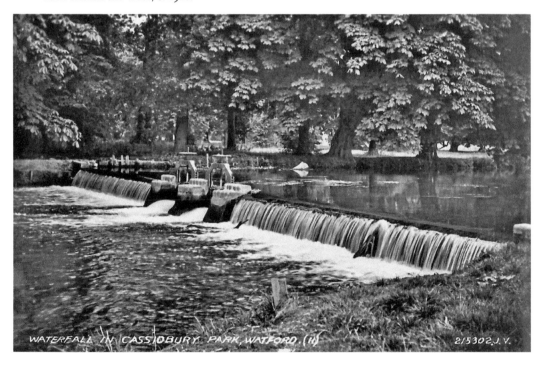

A fast-flowing River Gade with gate valves, remnants of which still remain in places.

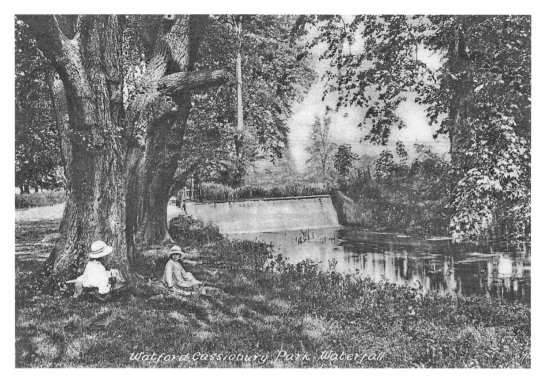

Dated from 1940, a pretty spot in the park by the waterfall.

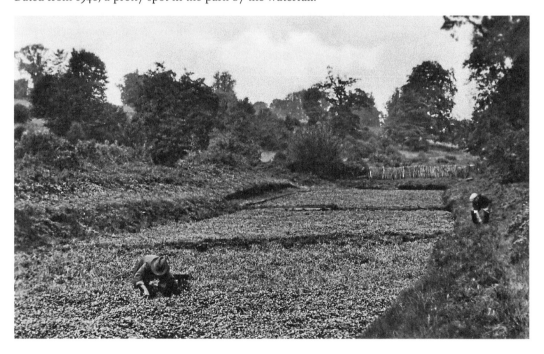

From April 1758, there are several references to work on the 'New Waters' and 'Broad Water'. Such work has often been attributed to landscape gardener Humphry Repton, but this work was actually begun more than forty years earlier. The area was later occupied by working watercress beds.

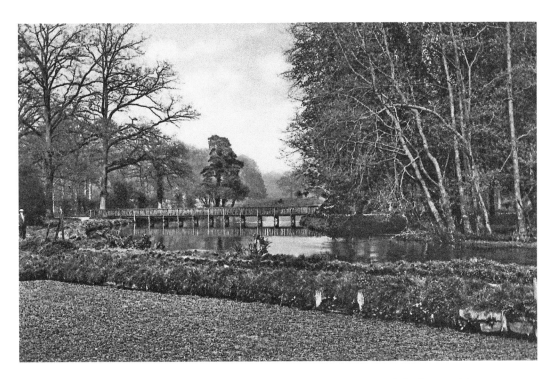

This image is from *c*. 1929. By the early 1990s, active management of the last working watercress bed had ceased and they fell into disuse.

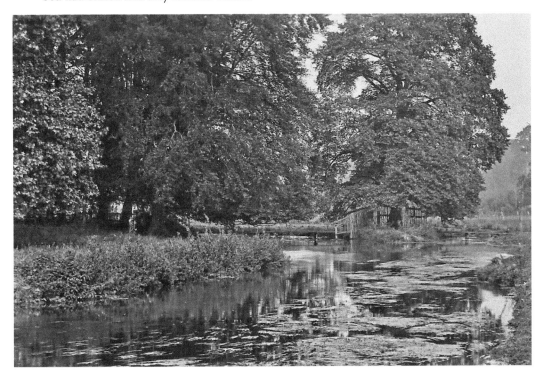

The River Gade meanders through this now very picturesque parkland.

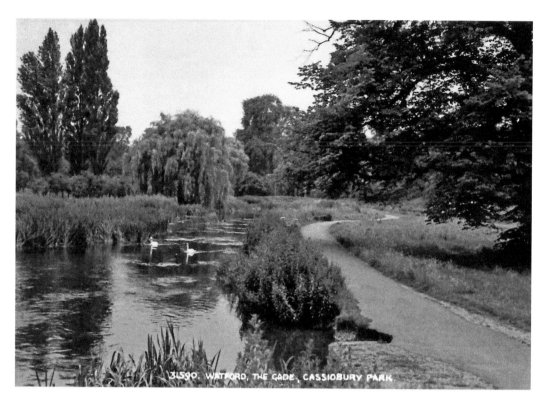

The River Gade meandering through the park.

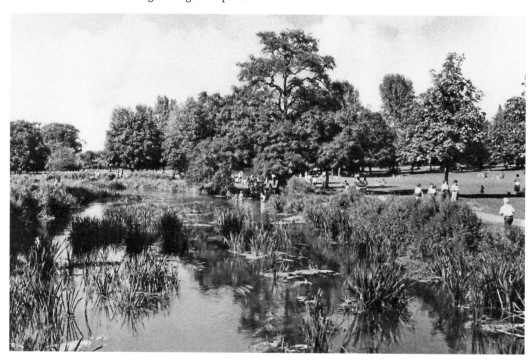

Dated 1963, the park is now popular with local people and families frequently taking picnics.

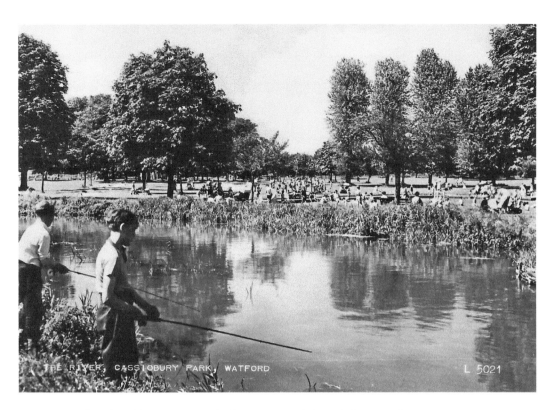

A wonderful parkland scene in the late 1950s with boys fishing in the river.

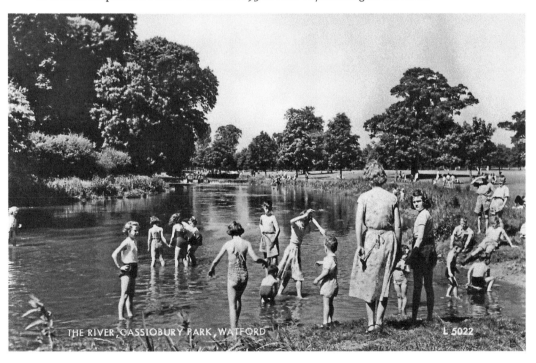

Another 1950s view: open parkland and paddling in the river – a major leisure and pastime.

1970s view of the river. There is yet no sign of the new paddling pools and kiosks that were introduced in 1983 at a cost of £250,000, replacing the original paddling pool by the River Gade.

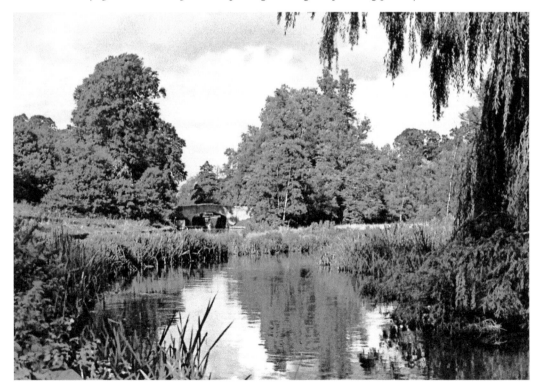

The River Gade and Iron Bridge Lock over the adjacent canal, 1970.

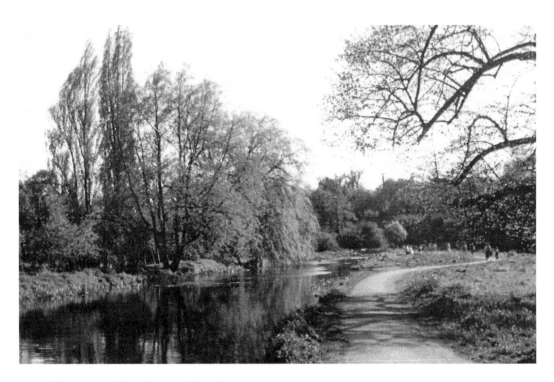

The River Gade and riverside walk.

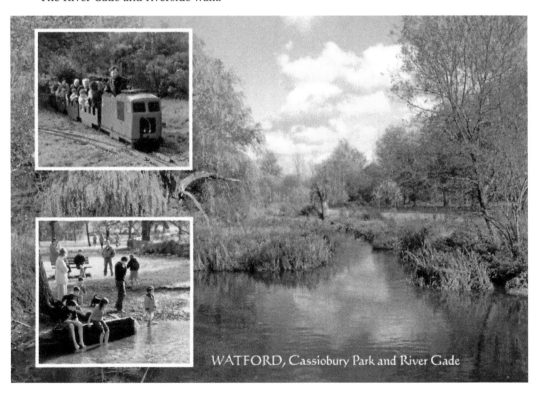

WATFORD, Cassiobury Park and River Gade

A public park with the River Gade at its centre – people at play. (Photo Bob Nunn)

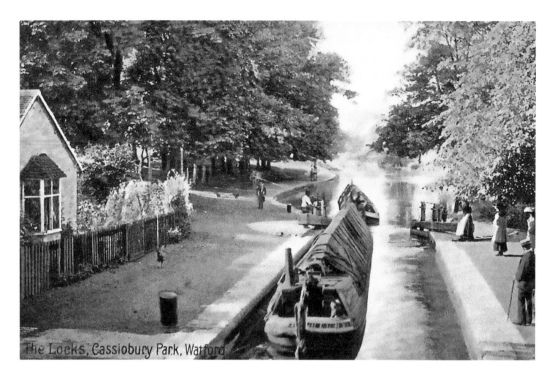

The Iron Bridge Lock and cottage, dated 1908. The writer of this postcard describes Watford as a 'decent place, something like Swindon'.

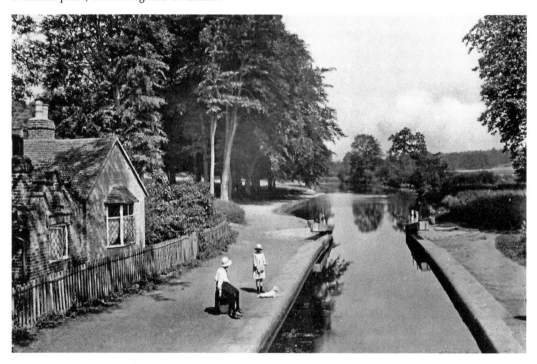

The Canal Company also had a watchman's cottage present 'to prevent the navigators from committing depredations in their passage through the park'.

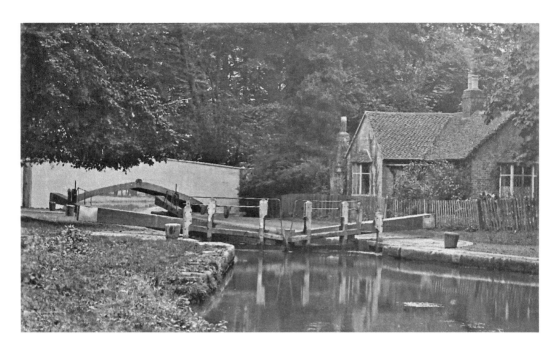

Both the canal and River Gade entered Cassiobury Park from the north as separate streams. There were two locks and a private wharf on the canal, below which the river rejoined it. They parted again above the mill, near where Iron Bridge Lock and two bridges carrying the drive that linked Home Park with High Park.

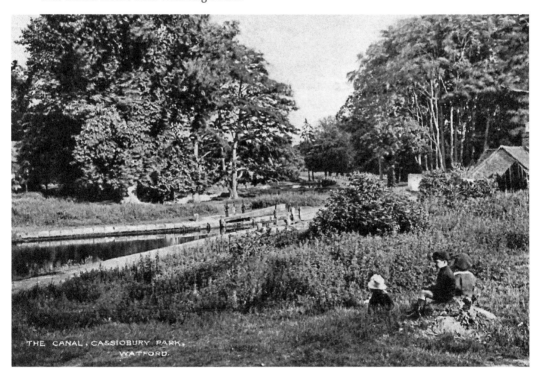

Canal and cottage with both Old Mill and bridge visible.

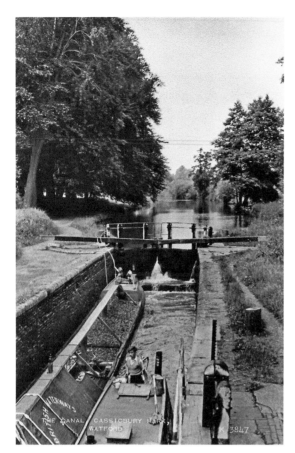

Left: The advent of the railways forced the waterways to adapt in order to survive. The duplication of locks at Stoke Bruerne and the ascent of the northern slope of the Chilterns is an early example of attempts to speed up traffic on the Grand Junction. Despite reductions in tolls because of railway competition, the canal stayed profitable and was very much a working canal for many years after the railway age – as is evident here in Cassiobury Park.

Below: A peaceful scene in Cassiobury Park, by the Grand Junction Canal.

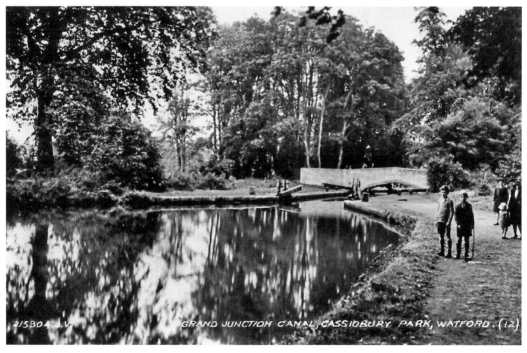

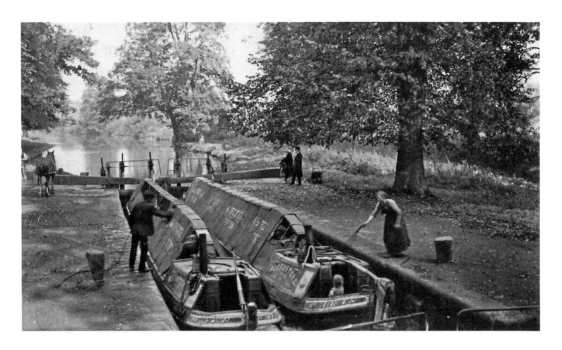

The waterway is still very much a working canal – *c.* 1914.

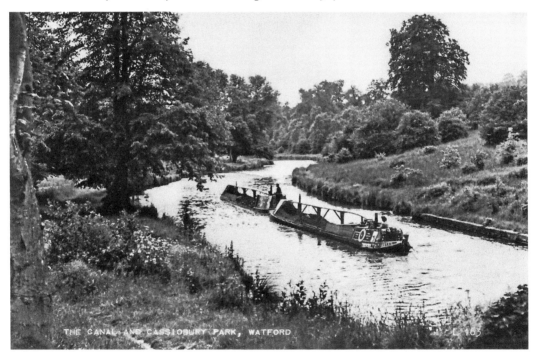

THE CANAL AND CASSIOBURY PARK, WATFORD

The Grand Junction Canal was built to improve the communications between Birmingham and the Midlands and London. It received its Act in 1793 and was fully opened in 1805. Its major engineering works were the two long tunnels at Blisworth and Braunston, and the long and deep cutting at Tring summit. Branches were added: to Paddington (opened 1801), Buckingham (1801), Northampton (1815) and Aylesbury (1815) and to Newport Pagnell (opened 1817).

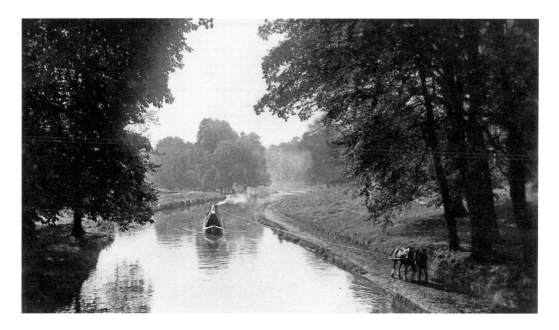

The canal was always viewed as a visual asset to the park, often animating the scene with draught horses and colourful craft. There are four locks rising northwards along the meandering section of canal in the park. The sweeping nature of the canal is due to demands placed on the builders of the canal by the Earls of Essex.

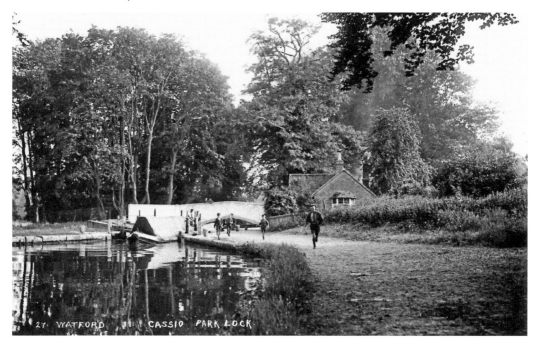

Although the Grand Junction was built as a broad canal and could take boats 14ft wide, at its northern end it joined the narrow Oxford Canal and the canals that continued the line to Birmingham were also narrow. In practice, therefore, it was generally used only by narrowboats, except at the London end.

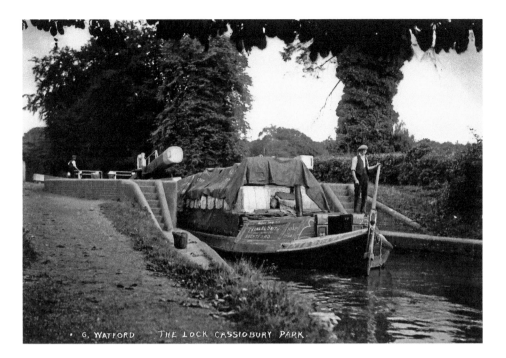

The canal had water supply problems, especially for the summit between Marsworth and Tring. A navigable feeder was made to Wendover (1797) and several reservoirs with pumping engines built near the junction. Over the years, back-pumping was introduced at many of the locks.

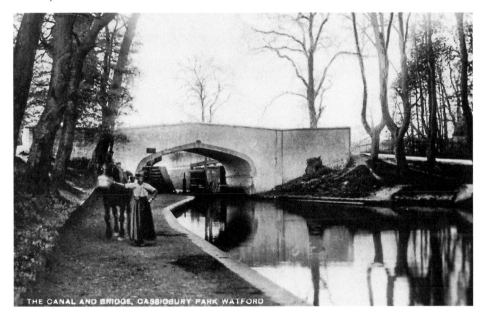

The advent of the railways forced the waterways to adapt in order to survive. The duplication of locks at Stoke Bruerne and the ascent of the northern slope of the Chilterns is an early example of attempts to speed up traffic on the Grand Junction. Despite reductions in tolls because of railway competition, the canal stayed profitable.

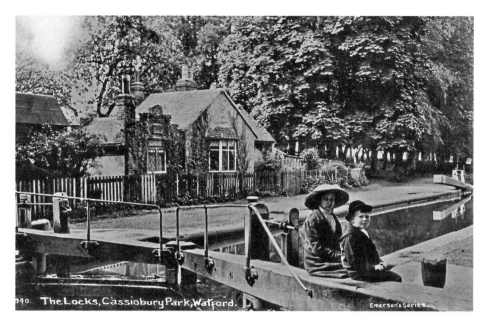

The Locks, Cassiobury Park, Watford. Emerson's Series.

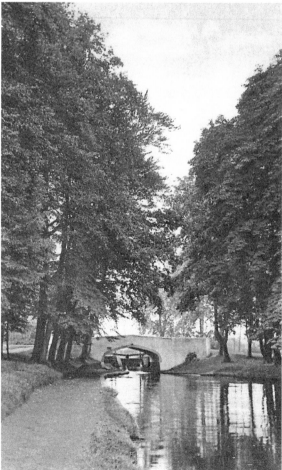

Above: Ironbridge locks with cottage, *c.* 1913.

Left: Iron Bridge Lock and the Gothic 'Iron Bridge', which carries the historic western approach to the former house over the canal (the bridge is so called because of the former iron cage and estate rail that enclosed it, of which traces are just visible).

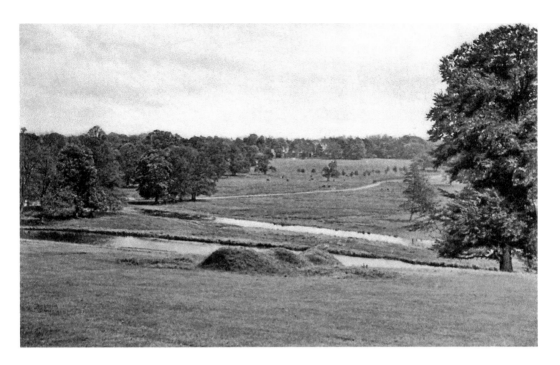

Dated 1923, a view across the golf course towards the house, just visible, but with the open course of the Grand Union Canal, River Gade and the parkland. New tree planting by the council is abundant.

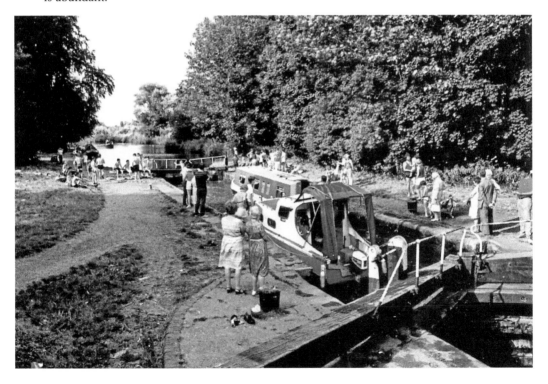

Iron Bridge Lock in the 1970s. Leisure boating is the fashion.

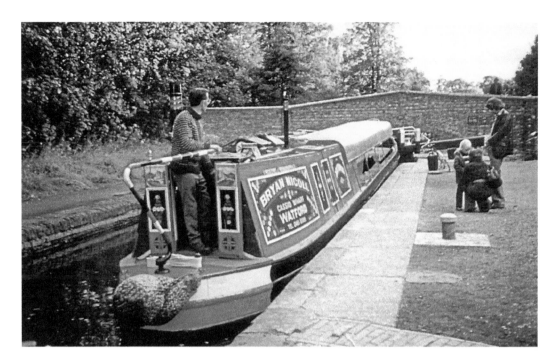

Navigating through Iron Bridge Lock *c.* 1970s.

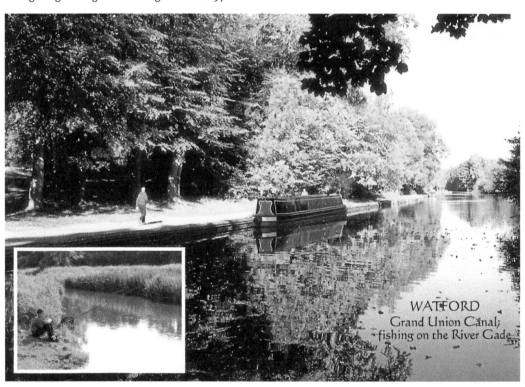

Both the canal and river are peaceful waterways today, whether boating for leisure, living here or simply fishing. (Courtesy of Bob Nunn)

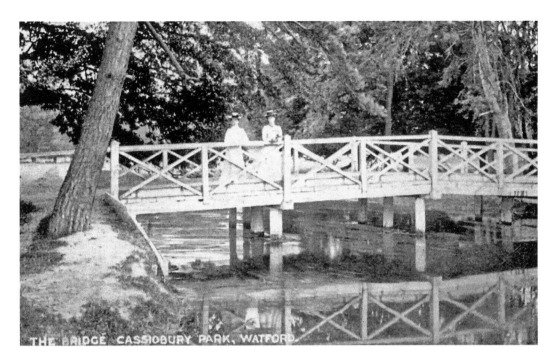

The original 'rustic bridge', the scene of many Victorian picture postcards. This entire area is of considerable historic significance due to the visible relics of some of the working parts of the former estate, notably the watercress beds, Old Mill remains and weirs, and also for the remains of designed views to the former house. Image *c.* 1905.

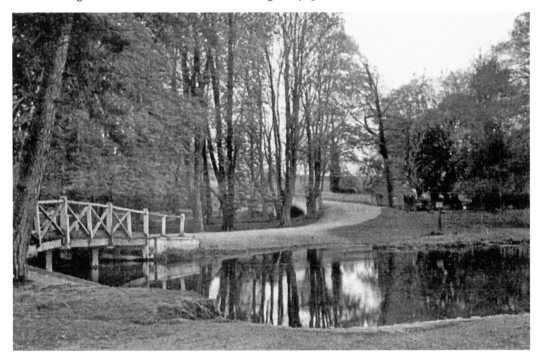

Dated 1915, the rustic bridge, a quiet river crossing and the Iron Bridge Lock.

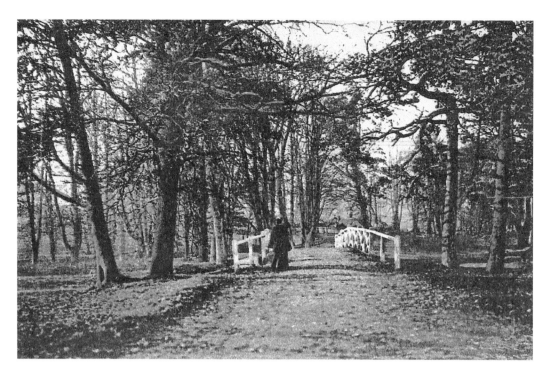

An almost windswept view towards the rustic bridge, which was still part of the estate, *c.* 1906.

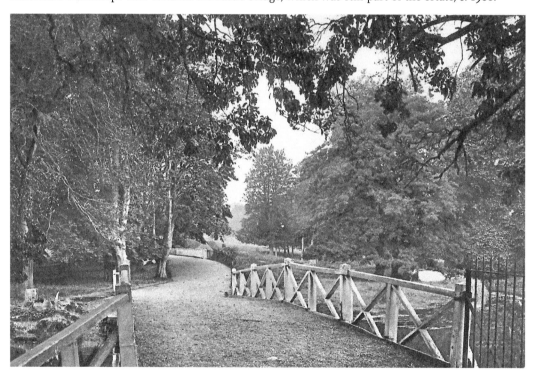

A tinted postcard dated 23 September 1930, and now public parkland with well-surfaced footpaths and municipal railings by the bridge.

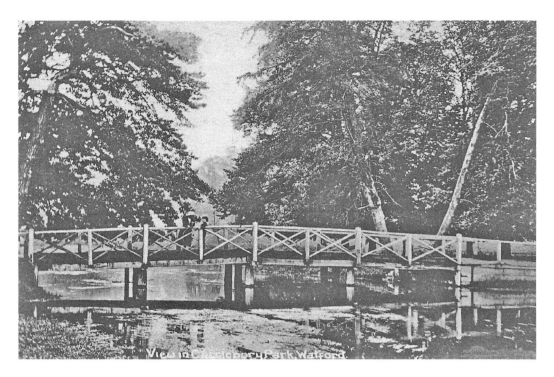

A picturesque view of the rustic bridge, dated 1915. Ida is 'staying here for my holidays this week and like it very much'.

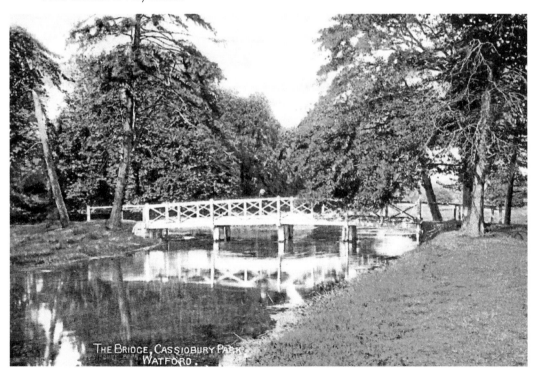

An equally beautiful view across the River Gade from the early 1920s.

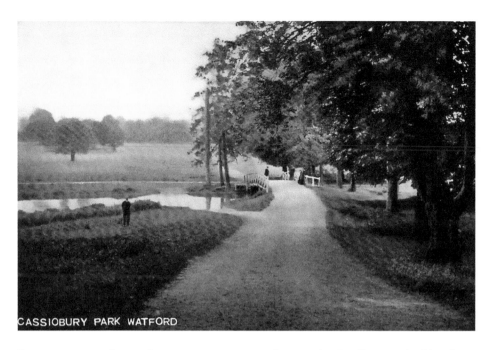

CASSIOBURY PARK WATFORD

Between 1900 and 1910, the country estate stretches out in the distance, looking from the Iron Bridge. Mature trees and an open river are visible, but only a few years later it was to be sold to the Watford Urban District Council and further avenues of trees were planted and a new paddling pool introduced nearby.

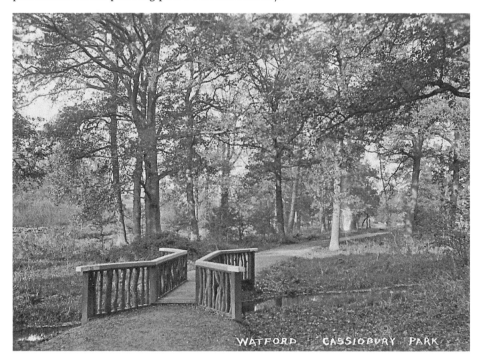

WATFORD CASSIOBURY PARK

Dated 1924, the writer complains that 'it seems to me all the postcards I can get of the new part of the park here are almost alike'.

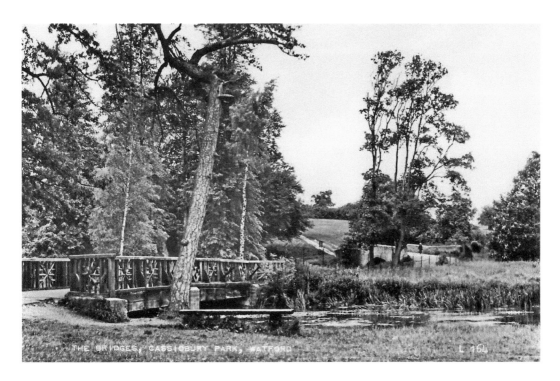

The later 'rustic bridge' on the site of the original delicate structure of the same name, *c.* 1940. The river has more vegetation and the crossing has disappeared with a park bench in place. The Iron Bridge Lock cottage has been demolished.

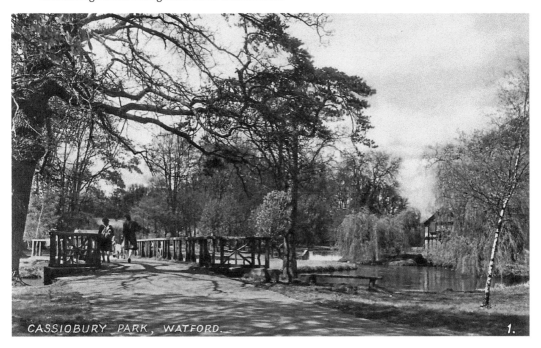

Probably late 1940s to early 1950s (the Old Mill was gone by 1956), the rustic bridge with river and mill nearby were one of the most popular spots in Cassiobury Park.

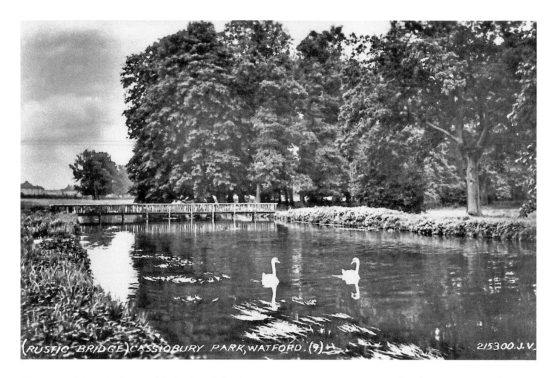

The open River Gade, established parkland. Houses are now present in the distance, possibly Gade Avenue.

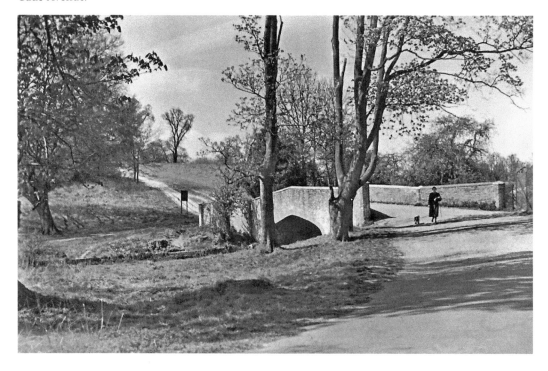

The Iron Bridge over the Grand Union Canal. A footpath is leading up to West Herts Golf Club, *c.* 1956.

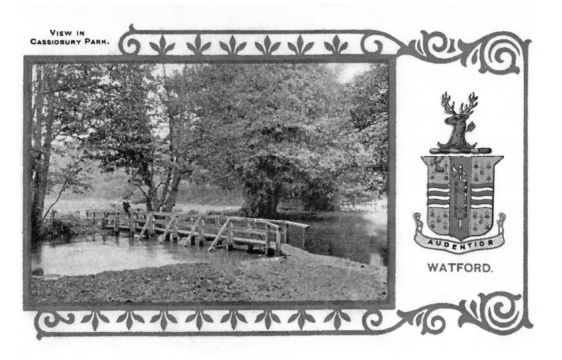

VIEW IN CASSIOBURY PARK.

AUDENTIOR

WATFORD.

The splash bridge, as it was called, close to the Swiss Cottage and Cassio Common, *c.* 1924.

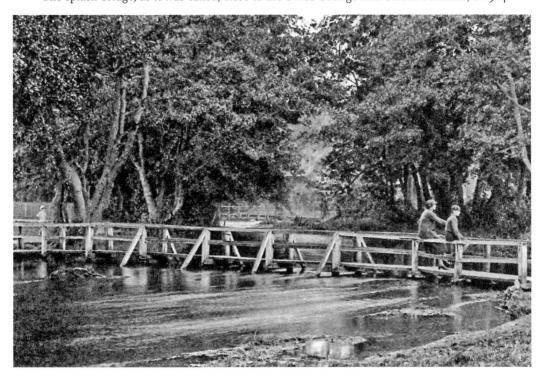

The splash bridge, with the Swiss Cottage in the distance.

Section 6
THE BANDSTAND

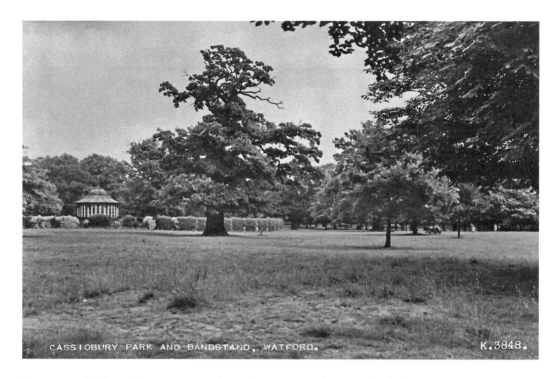

CASSIOBURY PARK AND BANDSTAND, WATFORD. K.3848.

It was a tender from Messrs Ensor and Ward, contractors from Watford, that was accepted for the erection of a Hill & Smith bandstand of Brierley Hill of the West Midlands bandstand in October 1911.

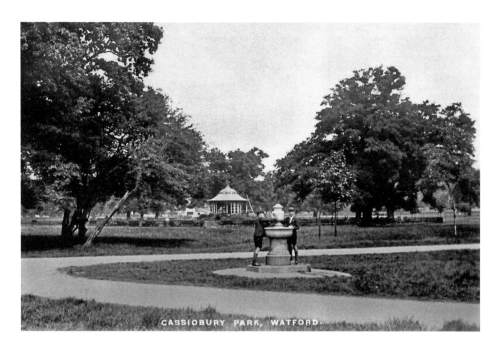

Bandstand and drinking fountain.

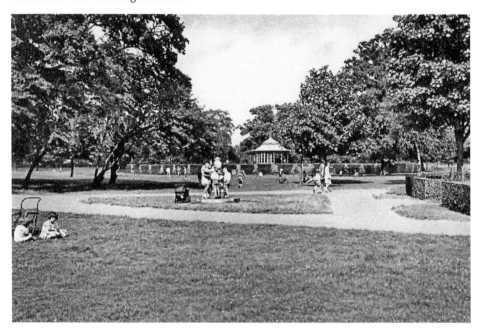

The *West Herts Post* on 20 September 1912 reported, 'Cassiobury Park Bandstand – this structure now appears to be shaping up under the supervision of Messrs. Ensor and Ward, builders and contractors, Watford, who have got the work in hand [and] will shortly complete the whole structure. It is to be hoped the fine weather will prevail... The opening of the new addition to the Park takes place on Wednesday afternoon at 4.30pm when the Artizan Staff Band will render a nice selection of music'. It was formally opened on the 27 September 1912.

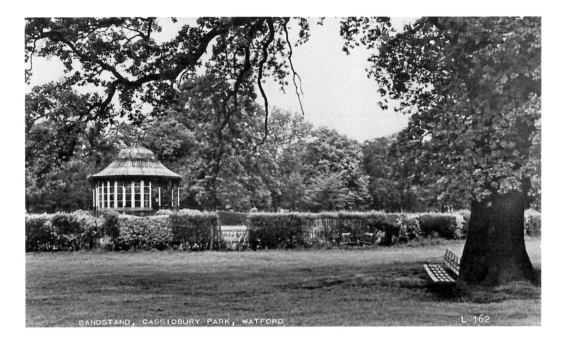

In 1930, sales brochures for local estate developments describe Cassiobury Park's natural amenities: 'with a band enclosure with seating for 1,500 people. First class military bands give performances every Sunday'. Screens are evident in this image and were later added in 1914, and there were proposals to extend the bandstand area between 1920 and 1923.

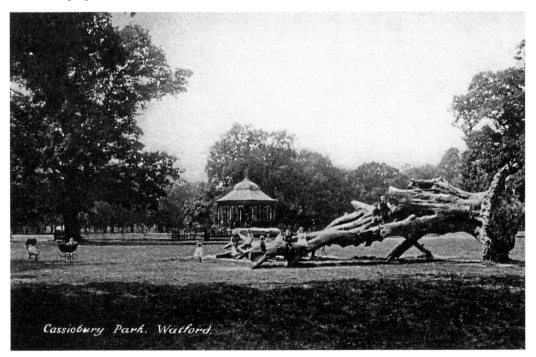

The enclosure has since been removed and the bandstand is open within the wider parkland setting.

74

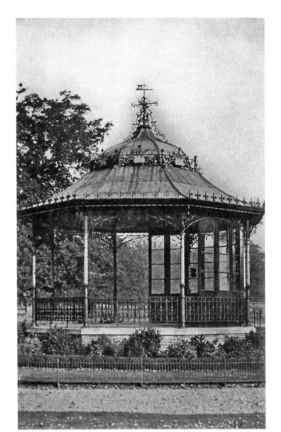

Right: Screens were movable and on runners, protecting bandsmen from the elements.

Below: The bandstand returned to the park in September 2016 and was opened by elected Mayor Dorothy Thornhill MBE and Head of Parks Paul Rabbitts, now painted in the colours of the Capel family tree, retaining the connection with the Earls of Essex. Watford Town Band, one of the original Watford brass bands, can be seen playing here in 2016. (Courtesy of Watford Borough Council)

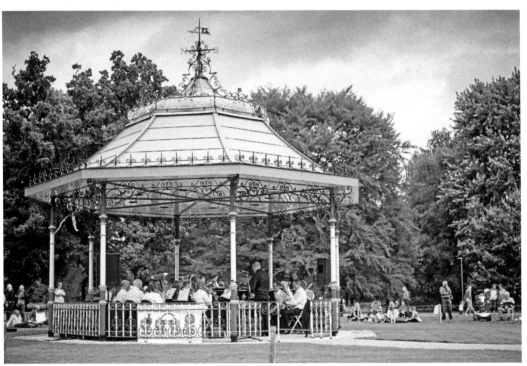

PARKLAND AND WOODLAND

Within the parkland setting are remaining buildings including the Cha Tea Pavilion and the popular paddling pools.

The house visible in the distance in the early 1900s, and a charming message on the back of the card reads 'Isn't this a nice place for a lark in the park.'

Open parkland, a flowing River Gade and the house in the distance. Tree planting by the Urban District Council is evident in the middle distance.

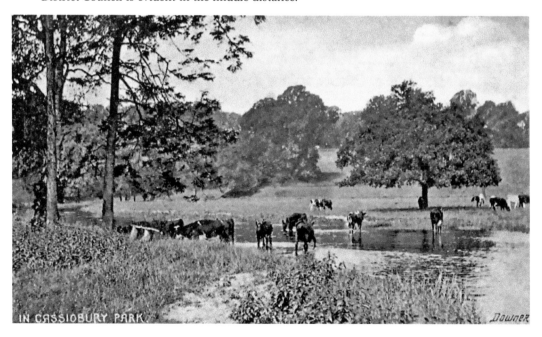

Early 1900s and cattle are seen grazing in Cassiobury Park.

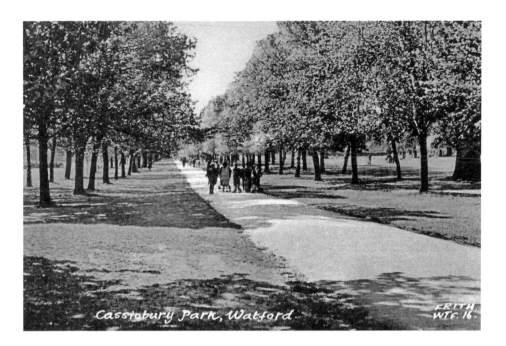

The local authority was proactive from the outset in planting within the park, as parcels of land were purchased from the estate. By the late 1950s, many of these new avenues of trees were becoming well established.

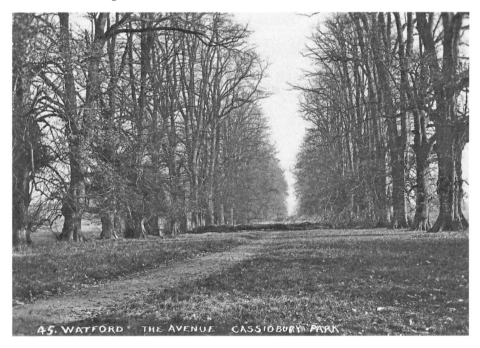

One of the main avenues in the park ran from the eastern side of Whippendell towards the house and, according to a later visitor in the late eighteenth century, it was described as aligned to the summer sunset: 'On a distant rising ground you look along a very broad avenue of limes, exactly at the end of which, during a part of the summer, the sun sets...'

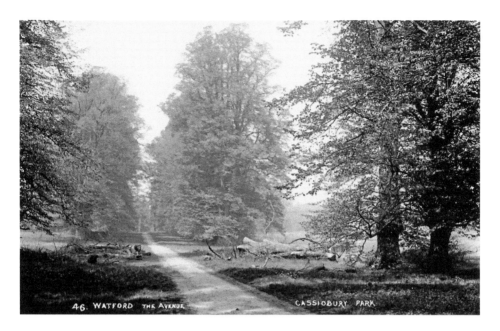

Moses Cook recommended the use of limes, elms and beech and the sowing of seeds only from the best specimens.

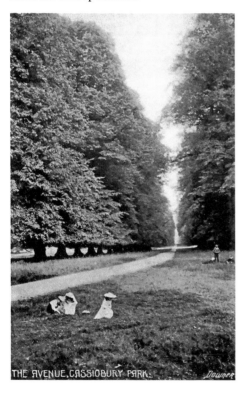
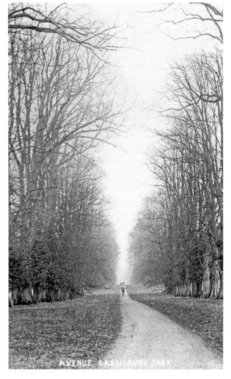

Above left: Early 1900s view of the Lime Avenue.

Above right: The Lime Avenue, now crossed by West Herts Golf Club.

Left: The avenue in full leaf looking towards Whippendell Wood.

Below: A tinted postcard, almost hinting at autumn colours, with the gap catering for the golf course clearly evident.

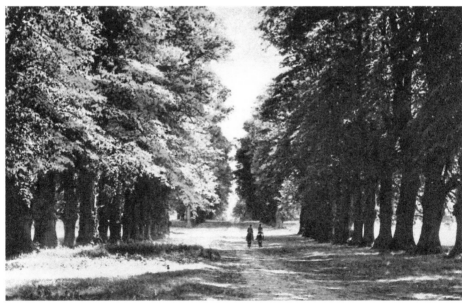

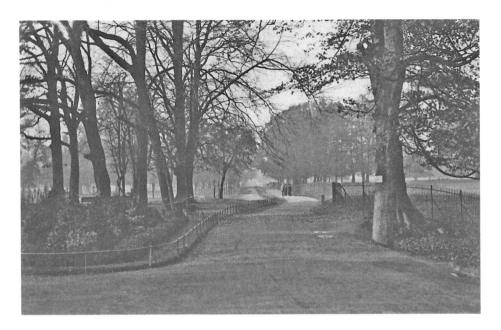

Dated 1916, in Cassiobury Park there are areas that are now clearly open public parkland to the left of the footpath, with low-rail, new tree planting and ornamental planting, but the right-hand side is still enclosed with tall railings. At the turn of the twentieth century, the deer were also still present and at times causing havoc, often getting into the gardens. After one incident, after devastating the vegetable garden, 'all the deer disappeared'.

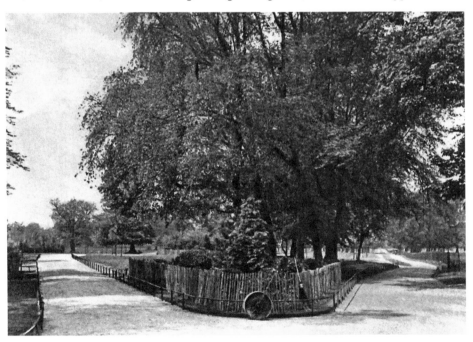

From the inside of the Cassiobury Park gates, the view down the park and the presence of park maintenance – a roller and sweeping brush, and protective fencing for new planting, c. 1926.

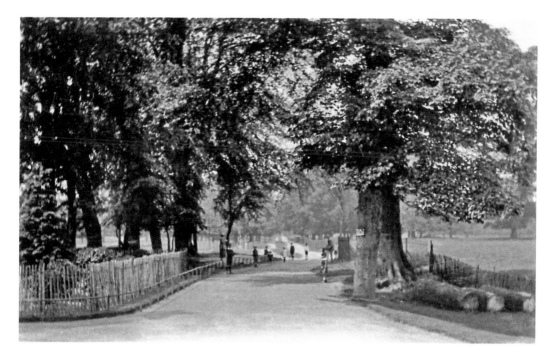

Dated 1933, the park is popular with children playing in the distance.

A family enjoying Cassiobury Park.

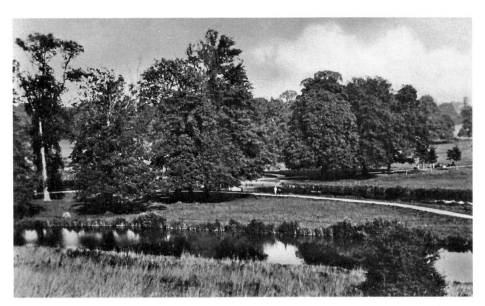

Above: *c.* 1936, looking up the park from the River Gade, and perambulators promenading in Cassiobury Park in the distance – as was the fashion of the time.

Right: A walk through a more secluded part of the park, *c.* 1954, now part of the Local Nature Reserve.

CASSIOBURY PARK, WATFORD. (1) 204548.JV.

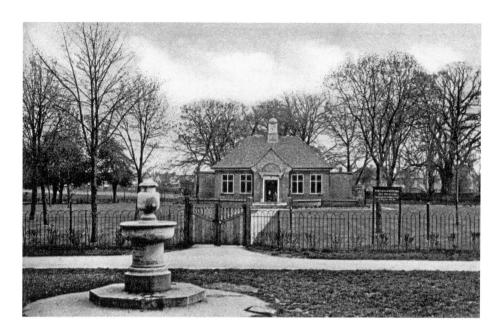

The Cha Tea pavilion built in *c.* 1926 in art deco style and with a fully functioning clock tower. The drinking fountain may have been erected later but was certainly in place by 1933. It was lost by the late 1960s and was finally replaced in 2016.

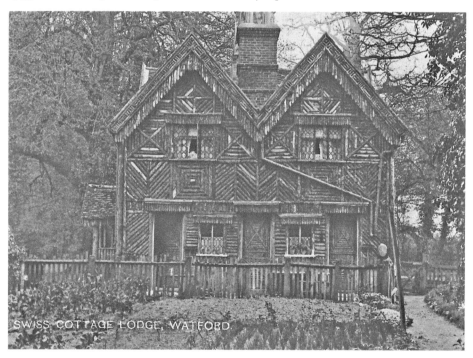

SWISS COTTAGE LODGE, WATFORD.

At the southern tip of the park is the most unusual lodge – that still remains. This is the Grade II-listed Cassiobridge Lodge (now at No. 67 Gade Avenue), described by Britton in 1837 as 'the most elaborate in execution; its whole exterior being covered, or cased with pieces of sticks of various sizes split in two', frequently confused with the Swiss Cottage.

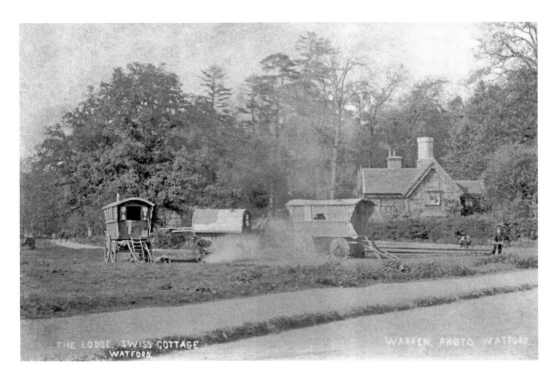

Cassiobridge Lodge was built in Picturesque style with ornamental timber cladding and a prominent ornamented brick chimney stack.

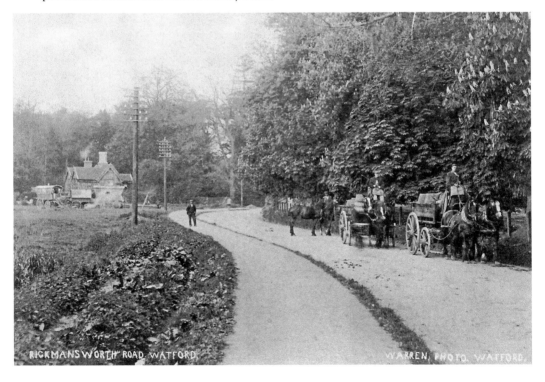

Looking back towards Cassiobridge Lodge, *c.* 1920.

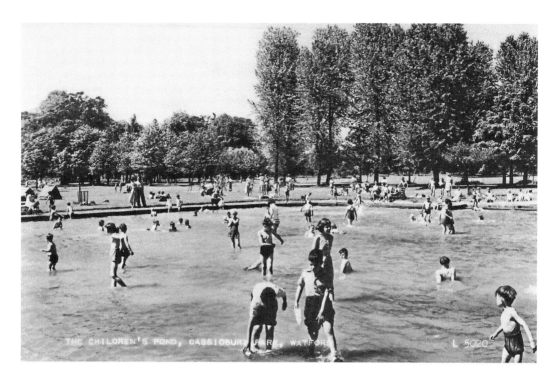

Paddling pools have been a feature in the park since the 1930s and were a major draw for local people. The view is from *c.* 1960, with families enjoying a day out in the park and paddling in the 'children's pond'.

The paddling pools in 1968, fed entirely with water from the River Gade.

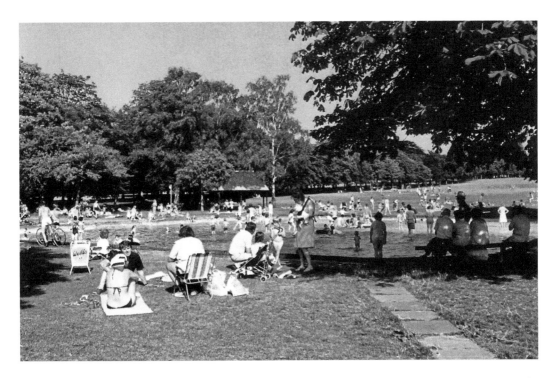

The original paddling pools in the 1970s. Families enjoy the hot summer weather.

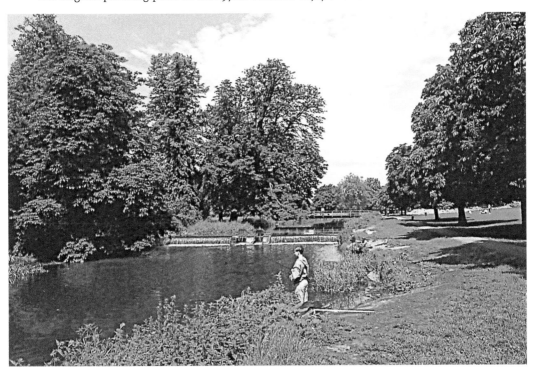

Late 1980s and popular as a fishing spot. In the background, the construction of the pools has begun.

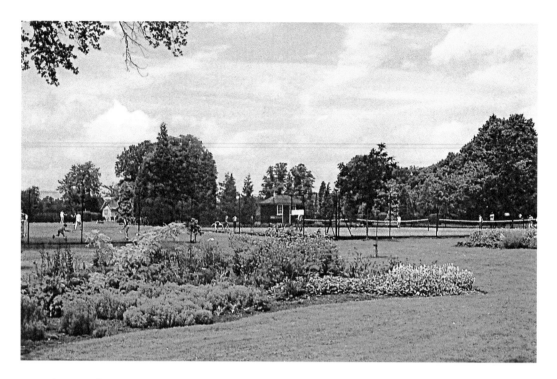

Cassiobury Park tennis courts. At the height of its popularity there were twenty-three tennis courts in the park with fourteen in one stretch to the rear of Cassiobury Park Avenue. By 1999, there were fifteen grass courts in total. By 2017, there were less than ten and all the courts behind Cassiobury Park Avenue had been removed and returned to parkland.

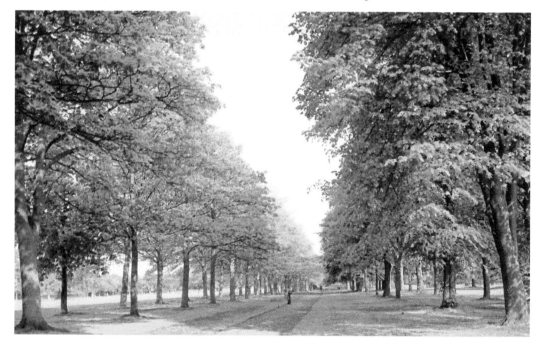

Cassiobury Park is famous for its grand avenues – and they are maturing well.

Autumn in Cassiobury Park, a view from the 1980s.

A winter walk in Cassiobury Park.

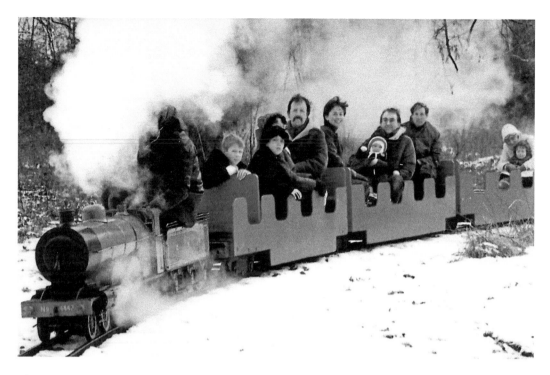

The model railway was introduced to the park in 1959 and remains to this day. Many parks in the country still have miniature or narrow-gauge railways, from Hammonds Pond in Carlisle to Eaton Park, Norwich, and Mote Park in Maidstone.

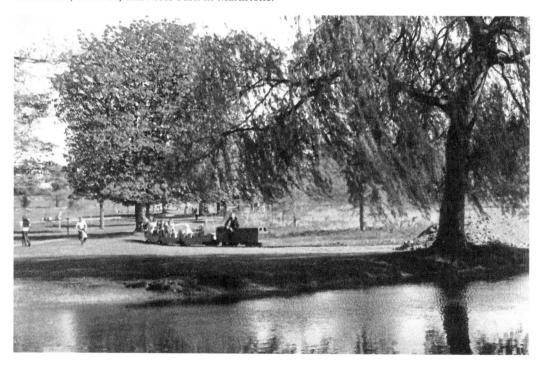

The model railway.

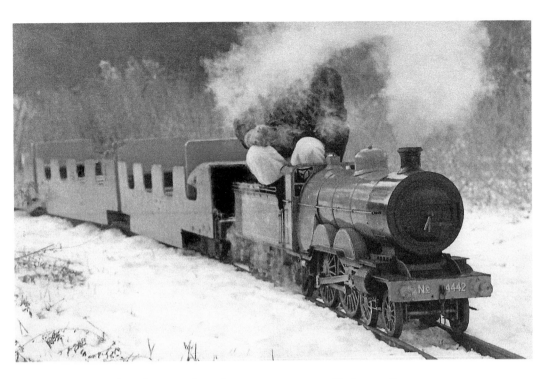

The model railway has even been known to operate on Christmas Day.

A view from the late 1980s. The new paddling pools are in the distance with the kiosks, erected in 1983 at a cost of £250,000, demolished in 2016 and a new restored pools facility opened in 2017.

Rose Barn Lane, leading into the depths of Whippendell Wood, now known as Rousebarn Lane – a quieter entrance.

With the availability of land from the sale of the Cassiobury Estate, the council were forward-thinking having purchased land from 1908 up to 1935 when they also purchased Whippendell Wood.

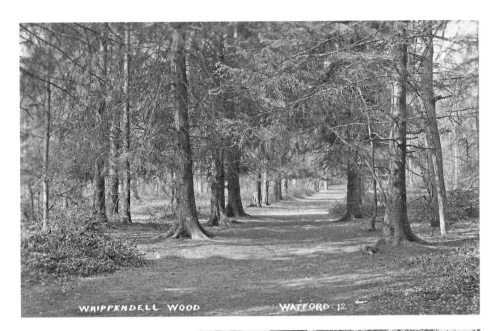

WHIPPENDELL WOOD WATFORD. 12

Above: Whippendell, described as a 'wood ground and deer park', suggesting that although primarily woodland, it was also grazed by deer and probably included some clearings – *c.* 1926.

Right: 1913 and a walk deep into Whippendell Wood.

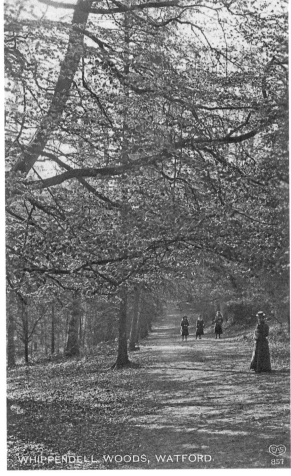

WHIPPENDELL WOODS, WATFORD.

857

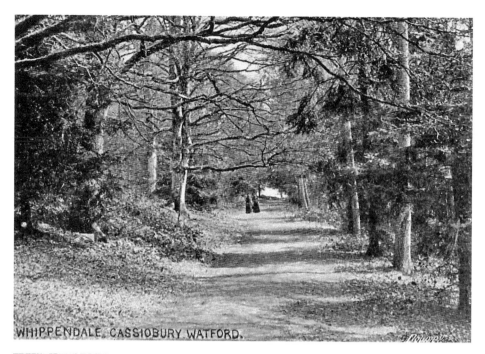

WHIPPENDALE, CASSIOBURY WATFORD.

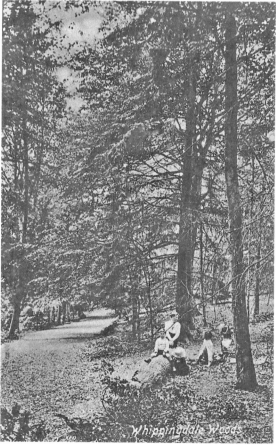

Whippingdale Woods

Above: Two ladies walking in Whippendale, Cassiobury, probably from the turn of the twentieth century.

Left: A family enjoying a woodland walk, *c.* 1924.

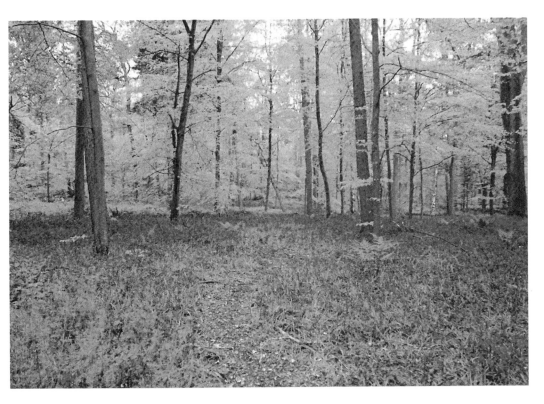

Whippendell Wood today and its carpet of bluebells resplendent every spring. (Courtesy of Sarah Priestley)

ACKNOWLEDGEMENTS

Paul Rabbitts would like to thank his colleagues at Watford Borough Council who appreciate Cassiobury Park as much as he does; in particular my co-author, colleague and friend Sarah Priestley, the real expert on Cassiobury, who has researched and collected Cassiobury Park for many years, as well as parks colleagues past and present. I am ever inspired by Page, Plant, Bonham and Jones and as always my family who tolerate my ramblings on all things parks related.

Sarah Kerenza Priestley has to start by thanking her co-author Paul for sharing the joy of creating a book – in fact two books – with her. A historian can't give a better gift of friendship.
 Collecting and sharing the history of Cassiobury is an ongoing story; I'm just a small part in it. I would like to thank my colleagues past and present at Watford Museum and Watford Council, in particular Luke Clark, Sonia Sagoo, Naina Vadgama, Hailey Baxter, Laura Horn, Gary Oliver, Tab McLaughlin, Sian Finney MacDonald, Lewis Butler and Gemma Meek.
 Thanks to Mary Forsyth, Laurie Elvin, Linda Nunn, Tony Cowham and Chris Orchard for their contribution to this book and the history of Watford, and to the Capell family for the gift of their friendship and heritage.
 My gratitude to Farzana Chaudry, Helen Giles, Ian Grant, Nick Hewitt, Morag Kinghorn, Catherine Evans and all my friends for their support. Lastly special thanks to my wonderful family for your encouragement and belief, in particular Lowenna.
 All images supplied by Watford Museum and especially from the collections of Laurie Elvin and Paul Rabbitts. Text edited from *Cassiobury: The Ancient Seat of the Earls of Essex* by Paul Rabbitts and Sarah Kerenza Priestley (Amberley Publishing: 2015).

ABOUT THE AUTHORS

Paul Rabbitts is Head of Parks for Watford Borough Council and is the author of many books on historic parks, including several on the Royal Parks, as well as being a recognised national expert on the Victorian bandstand. He is joint author of the definitive history of Cassiobury with Sarah Kerenza Priestley.

Watford-born Sarah Kerenza Priestley is curator of Watford Museum, the largest repository for art and information on Cassiobury, and has carried out extensive and original research into the history of Cassiobury for over fourteen years. She is an acknowledged and recognised expert on the subject.